FREEHAND

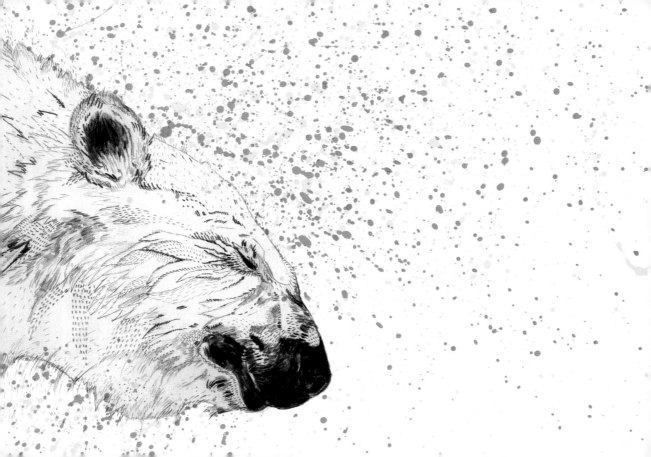

FREEHAND

SKETCHING TIPS AND TRICKS DRAWN FROM ART

by Helen Birch

CHRONICLE BOOKS

SAN FRANCISCO

Dedicated to: Joyce (Cooper) Birch and Jo "Fuzzbox" Dunne

First published in the United States in 2013 by Chronicle Books LLC.

Library of Congress Cataloging-in-Publication Data available.

ISBN: 978-1-4521-1977-9

Manufactured in China.

Design/layout: Lucy Smith/The Entente and Jennifer Osborne
Cover design: Sarah Higgins
Art Director: Emily Portnoi
Art Editor: Jennifer Osborne

10 9 8 7 6 5 4 3 2 1

Chronicle Books LLC
680 Second Street
San Francisco, CA 94107

www.chroniclebooks.com

Image Credits

Front cover (clockwise from top left): Ana Montiel, Craig McCann, Whooli Chen, Bryce Wymer, Julia Pott, Sophie Leblanc, Marina Molares, Isaac Tobin

Back cover (clockwise from top left): Stephanie Kubo, Nayoun Kim, Manuel San Payo, Sophie Leblanc, Diego Naguel, Hollis Brown Thornton

Page 2: Sandra Dieckmann and Jamie Mills (see entry, page 180)
Page 5: Carine Brancowitz
Page 7: Frida Stenmark (see entry, page 70)
Page 15: Sandra Dieckmann
Pages 16/17: Chris Keegan
Pages 192/193: Stephanie Kubo (see entry, page 108)

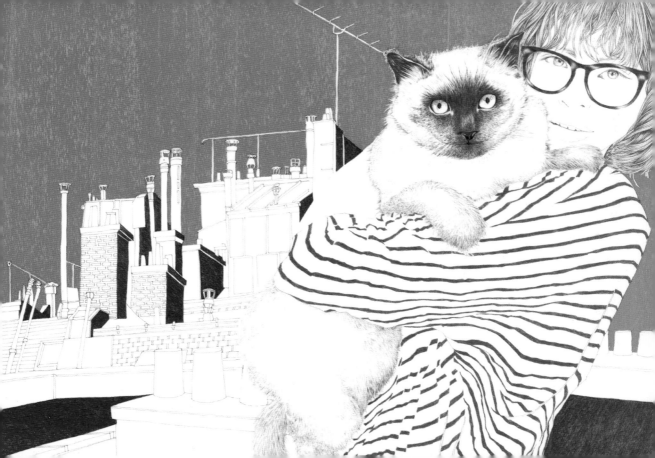

Flicking through this book

In addition to the contents listing opposite, we have included category and visual indexes to help you dip in and out of this book. Use these to find specific information or illustrations quickly.

Category index

We have used four main categories to highlight the techniques and qualities of every illustration and make it easy for you to compare similar subjects and styles. These four categories—principal element, medium, type of drawing, and subject—are indicated by the series of icons included with each illustration, and listed in the full category index on pages 8–9.

Visual index

Because *Freehand* is as much about visual inspiration as it is about technique, we have also included a visual index on pages 10–13. If you are trying to find an image you have already seen in the book, or looking for a specific style, color, background . . . use this to take you straight to the right page. Page numbers are given on the thumbnail of each illustration. Please note that where more than one illustration is included in an entry, only one is included in this index.

Teardrop details

So that you can see the finer marks of larger and more elaborate drawings, we have included "teardrop details" to enlarge a section of the drawing and give you a close-up view.

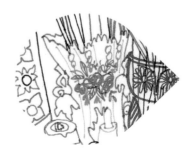

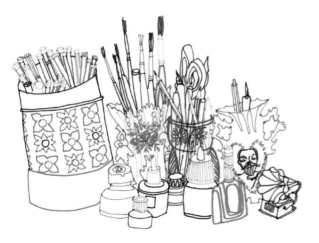

Principal Element

Color 20, 34, 36, 42, 46, 52, 58, 66, 68, 70,72, 76, 82, 88, 92, 94, 100, 106, 108, 112, 116, 118, 120, 132, 142, 144, 146, 158, 162, 170, 172, 174, 178, 182, 184

Shading 102, 142

Line 18, 22, 26, 30, 32, 38, 44, 46, 50, 52, 56, 58, 60, 62, 64, 66, 70, 72, 76, 80, 86, 92, 96, 98, 102, 104, 106, 108, 110, 114, 122, 130, 132, 134, 140, 146, 148, 150, 152, 154, 156, 158, 160, 164, 168, 172, 174, 176, 180, 184, 188, 190

Composition 40, 52, 56, 62, 64, 78, 92, 98, 128, 130, 136, 138, 150, 160, 176, 178, 186, 188

Tone 24, 28, 32, 52, 56, 62, 80, 86, 90, 120, 122, 126, 162, 166, 188

Texture 48, 60, 86, 94, 128, 144, 156, 166, 168, 180

Scale 98, 104, 120, 140, 152

Layers 20, 22, 26, 30, 38, 48, 54, 60, 68, 78, 88, 90, 96, 110, 112, 116, 118, 120, 126, 132, 152, 154, 160, 164, 178, 184, 190

Format 54, 108, 112, 172

Construction 18, 20, 44, 50, 182

Medium

Felt-tip pen/fineliner 20, 22, 30, 34, 60, 62, 70, 72, 80, 82, 104, 106, 108, 110, 120, 132, 140, 142, 144, 146, 152, 154, 158, 178, 188, 190

Marker pen 34, 36, 92, 144, 148, 152, 170, 176

Ball-point pen 52, 76, 82, 102, 120, 128, 136, 176, 188

Gel pen 44, 154

Fluorescent pen 144

Crayons 112, 118

Graphite pencil 24, 46, 56, 58, 64, 66, 72, 96, 116, 120, 122, 130, 136, 142, 172, 174, 180, 182, 184, 190

Colored pencil 94, 100, 158, 172, 180, 182, 184

Colored ink 22, 38, 40, 42, 66, 86, 90, 96, 100, 112, 126, 154, 160, 162, 164, 168, 180, 186

Black ink 18, 26, 32, 38, 40, 50, 58, 66, 98, 136, 184, 186

Watercolor 46, 54, 56, 86, 100, 126, 142, 162

Oil pastel 58, 100, 112

Paint 96, 174

Charcoal 26, 116

Gouache 72, 100, 112, 172

Paper 92, 96, 135, 166

Graph paper 80, 132

Colored paper 32, 62, 68, 164, 182, 186

Sketchbook 30, 66, 72, 102, 108, 122, 152, 176, 188

Found surface 148

Wax resist 86

Bleach 126

Spirograph 138

Brush 42

Ruler 108, 152

Compass 108

X-ACTO knife 78, 114, 134, 150, 182

Image editing software 22, 28, 48, 54, 88, 106

Digital 18, 20, 26, 40, 60, 88, 110, 120, 136, 142, 154, 186

Smartphone/tablet 156

Collage 20, 72, 92, 138, 166

Found paper 38, 78, 112, 118, 120, 150, 170, 178, 190

Acrylic paint 116

Print transfer 166

 Type of Drawing

 Subject

71

81

91

97

59

65

73

83

99

61

67

77

87

93

101

63

69

79

89

95

103

147
153
161
169
177
185
149
155
163
171
179
187
157
165
173
181
189
151
159
167
175
183
191

What is Drawing?

Drawing is something we do contentedly and naturally from a young age. It's only when we become aware of how others might judge our drawings that many of us begin to believe we can't draw, and either criticize our own drawings harshly or give up.

Too many people see drawing as a magical conjuring trick—something you have to have an innate talent for—but this is not the case. If you want to draw, the most important thing is to be interested in it. If you enjoy the drawings of others, and are excited by the possibilities, want to handle drawing materials, or simply wish to have a go at it, you're already more than halfway there.

In basic terms, drawing is marks made on paper. But it can be much more. Think about the times you do it unconsciously: making marks in the sand, doodling while on the telephone, running your finger through condensation on a window, moving the cursor around a computer screen, or filling in the loops of letters in a piece of text. The aim of the diverse examples in this book is to give you the confidence to consciously try new ideas, or to reappraise any you have already had. You may wish to emulate the subject matter you see here, try out the drawing materials described, or both.

Drawing is such an easy thing to do, and it uses such basic equipment. It can help you focus on your surroundings or experiment with ideas prompted by color, texture, line, composition, and more. Digital drawing apps have extended this range even further.

You don't have to have an aim for your drawing. It can be about relaxation or visual energy. There doesn't have to be a goal, though you may have one. Drawing can be instinctive, emotive, or intellectual. Your may have big ambitions, or sketch as a passing fancy. You could be an art student, or draw as a hobby. Whatever, whoever, drawing is a great thing to do.

Background and Space

Marina Molares

These two landscapes share a number of characteristics: both are monochromatic, both are repeat patterns, and both were drawn using black pen and constructed digitally. The contrast between them lies in Molares' use of space. She has laid out the telegraph posts so that the background paper shows through. The tone of the paper is an important part of this subdued design. For the other landscape she has packed lots of shapes into a confined space. Only the non-filled mountains allow the white of the paper to show through, and around these Molares has used heavier black lines to emphasize the contrast of tone.

Much of the skill here is in Molares' selection of what to draw, and how to draw it, before creating digital repeats. Both the looping, rhythmic wires of the telegraph posts and the dome-like mountains make great patterns.

 Line, construction

 Black ink, digital

 Monochrome, design

 Landscape

If you have Photoshop or Illustrator, look for pattern-repeat workshops online. There are also software programs designed to create a seamless pattern.

See page 25 for another example of repeated shapes creating a landscape.

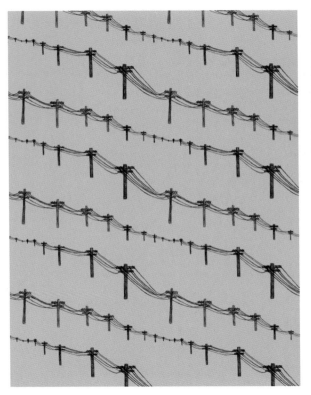

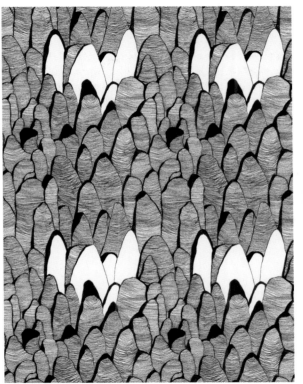

Alternative Reality

Julia Pott

This drawing is a good example of balance between real-world reference and imagination, experimentation and design. Pott has nestled her animals together in a digital collage, as though they are posing for a group shot. This adds to the human character Pott has imbued her quirky creatures with. All of this sets the scene for an alternative reality, allowing Pott's experimental moments—a hint of Spirograph patterning, a rubber-stamped date, random circles and diamonds—to sit comfortably and not appear out of place.

 Construction, layers, color

 Felt-tip pen, digital, collage

 Imaginative, reference

 Animals, birds

Pott achieved the perfectly flat colors of her animals by drawing them part by hand and part digitally.

You can see other examples of alternative realities on pages 27, 49, and 79.

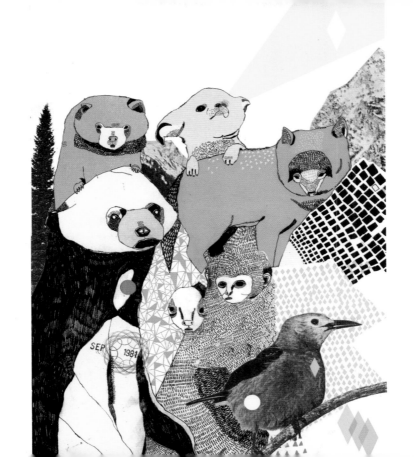

SEP 1981

Blended Layers

Paula Mills

This is a drawing of many layers, blended through digital manipulation: color and line are immediately apparent, but texture is involved too. Mills has confidently brushed a strong color onto a textured paper. The clean pen lines provide an effective contrast to this. The top layer is the white-line drawing. She has drawn this in an informal way. She has been confident in using a natural, flowing line to lay on her block of cerise ink. Her methods are innovative. She has used several layers of pink—each one of a different opacity—lightened some layers, added images to others, and blended them together.

 Line, layers

 Fineliner, colored ink, image editing software

 Observational, digital

 Still life

The white line was probably not white at all to begin with, but converted digitally from black to white.

See pages 41, 165, and 203 for other images that use white on a colored background.

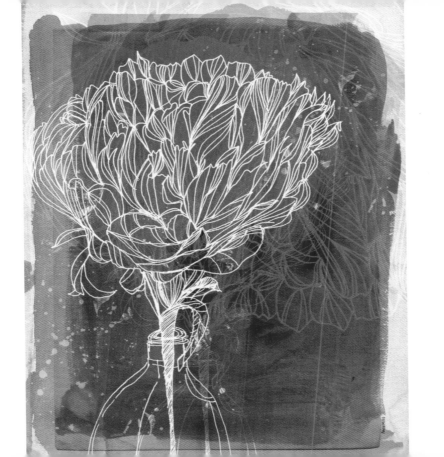

23

Aerial Perspective

Frida Stenmark

Stenmark has used aerial, or atmospheric, perspective for her densely wooded forest scene. This technique gives drawings a sense of depth and reality. When you look at a scene, features and objects appear lighter and less detailed as they recede. You can apply this observation to your drawings. Stenmark has used tone to replicate this effect: the gray of the trunks becomes steadily lighter from foreground to background, and the detail in their texture is also reduced. The bark of the tree trunks is described with densely packed vertical lines that echo the upright trunks. Essentially this is the same tree repeated over and over, but its size is manipulated to represent a fore-, middle-, and background. It really does feel like there is a distance in this drawing, but of course there can't be because this is a two-dimensional surface.

 Tone

 Graphite pencil

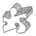 **Perspective**

 Landscape, nature

The same tonal rules apply for colored drawings: objects appear to lose color, or saturation, as they fade into the background. Any warm colors in the foreground fade to cool colors in the background.

Compare this perspective with that of the two images on page 19.

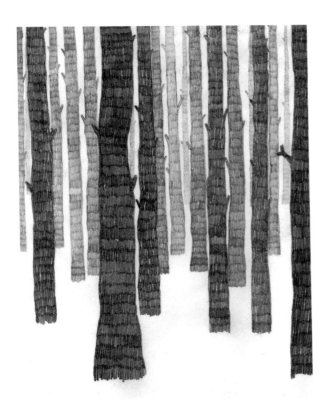

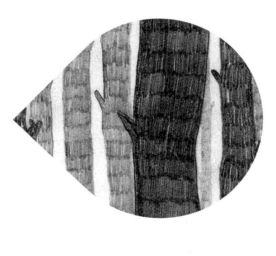

Digital Collage

Olya Leontieva

A landscape can be attractive without being beautiful. Leontieva has imbued machinery with human characteristics in this portrayal of an industrial scene. Personification is an important, and useful, concept in illustration as it can help to tell a story. Leontieva uses it here to suggest emotion and physical characteristics: the solitary crane on the left "looks" longingly toward a haughty group on a distant hill, while two small creatures "scurry" up another hill. Her varied use of black is also important here. She has used a black-gray wash and charcoal scribble along with thick black pen or chinagraph pencil and finer, scratchier, print-like lines. She has balanced these different techniques in a single illustration through digital collage, uniting all the elements through her marks on the hills and the sky.

 Line, layers

 Black ink, charcoal, digital

 Digital, collage, narrative

 Urbanscape

A similar technique was used for the images on pages 19, 21, 25, and 79.

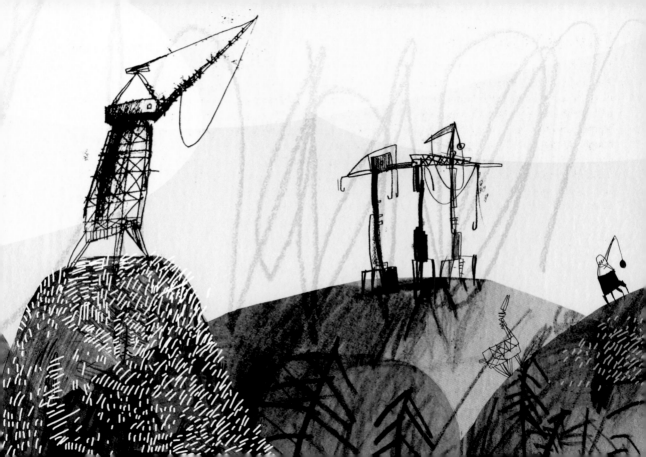

Black-and-White Silhouettes

Chris Keegan

This work began as a series of photographs of the cat, both in repose and moving. Keegan's editing of the photos is key to its success. He has used the contrast between black and white to great effect. There is a graphic clarity to the image because the difference in tone is as exaggerated as it can be. Using the cat silhouettes as frames leaves a clean, white background. Keegan has built up the cat forms by using silhouettes within silhouettes, selecting photographs of plants and landscapes with distinct outlines and removing all unnecessary detail digitally. The edges and black/white contrast are what count here. Keegan has used essentially the same fill for both of the cats, but has rotated, maneuvered, and placed the details to suggest different parts of the animals: a swirl becomes a cat's haunch or eye, bands of landscape become fur markings, and grasses are transformed into whiskers.

 Tone

 Image editing software

 Collage, digital

 Animals

You don't have to use a computer to try out collage effects like this. Try cutting silhouettes from magazine pages and newspapers, or from your own photographs, with an X-ACTO knife.

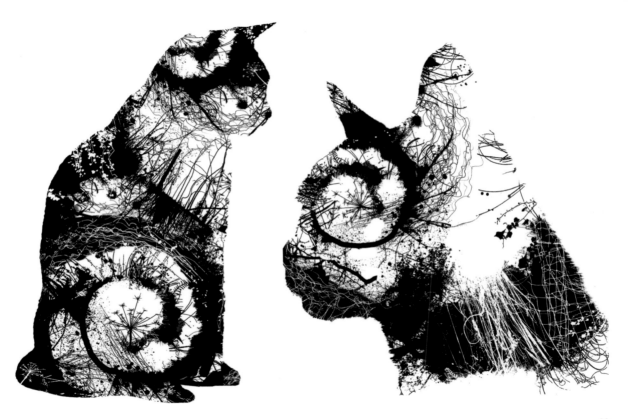

Borderless Sketch

Stephanie Kubo

There is an organic feel to this drawing, partly due to its floral subject matter, but also because of the way it "grows" across the space. Kubo's lines have a flowing, doodle-like quality, but she has added definition by contrasting the rounded petals with pointed leaves. Achieving such a flowing, pattern-like image is easier if you have a ready familiarity with your subject matter.

The other significant thing about this drawing is that the edge of the sketchbook hasn't hindered the flow of the design: there is no sense of a border. It is actually quite difficult to draw off or over the edge of a sheet of paper because the pen catches and snags. Kubo has overcome that difficulty and the drawing is better for it.

 Line, layers

 Sketchbook, felt-tip pen

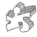 **Design, doodle**

 Pattern, repeat

The Moleskine sketchbook Kubo used is significant. These books have ivory-colored paper, rounded corners, and a stitched spine that enables them to lie flat when opened, which allows you to draw over the full width of the pages.

For alternative ways to use the full width of a sketchbook, see pages 73–75, 109, 177, and 189.

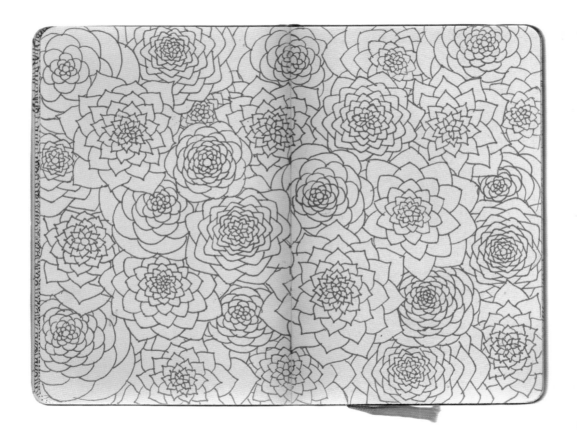

31

Balance

Pia Bramley

At first glance, the most striking thing about this drawing is the paper used. It is unusual to choose such a strong color as it can be difficult to work with something so dominant. However, when it works, it is really effective. Bramley's drawing is successful because her dense, black lines are equally strong. The perspective she has used is also interesting: she views the scene from a slightly elevated position. This suggests that Bramley drew the image mostly in situ. She has balanced the organic forms of the cacti and palm leaves against the inorganic interior space, and by adding a figure, she has given the drawing a sense of scale.

 Line, tone

 Colored paper, black ink

 Observational, perspective

 Interiors, nature

Draw wherever you are, but don't put pressure on yourself to finish a drawing on the same day. Develop a confident drawing shorthand, take photographs of the scene, then add more later, or redraw it and use your sketch and photograph for reference.

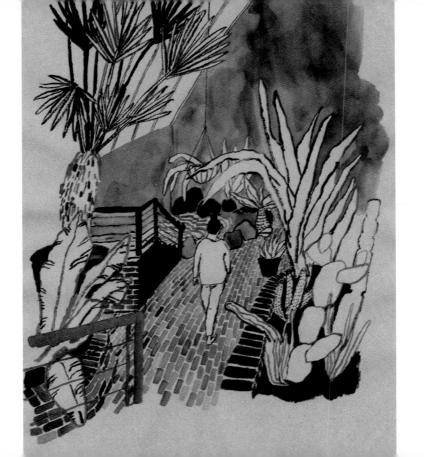

Bright Color

Ana Montiel

A doodle-like quality and Montiel's choice of bright colors transform this marker-pen sketch into a sophisticated yet lighthearted drawing. She has used just enough purple to offset her warm and sunny color palette. The interlocking triangles may appear, at first, to be random, but look again and you'll see that Montiel's structured repeat pattern echoes the construction of a patchwork quilt (explaining the name of the drawing—*Marker Quilt*). She has filled the triangles with pattern, like a fabric quilt, and included areas of solid color to create the illusion of three dimensions. The unusual square format adds to its appeal. Take advantage of the immediacy of the humble marker pen, and the doodle drawing style it encourages. Montiel has reassessed the possibilities both offer us.

 Color

 Felt-tip pen, marker pen, colored pencil

 Design

 Pattern, repeat

The images on pages 31, 109, 147, and 153 all use repeated shapes filled with patterns.

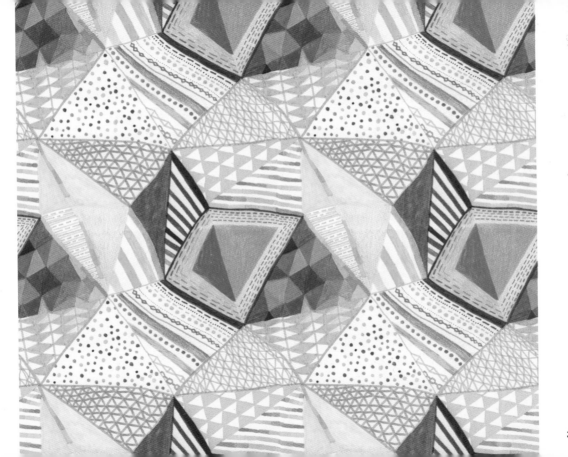

35

Color and Pattern

Hollis Brown
Thornton

The big attractions in this still life are the color and pattern within it. By using marker pens, Brown Thornton has ensured that the graphic, saturated colors on his stacks of VHS tapes lose none of their brightness. The way he has reproduced the writing on the labels is a labor of love. This drawing is extraordinary in many ways. It makes us pause and take note of something that evokes nostalgia; it reminds us how quickly technology is superseded. But the setup may not be as spontaneous as it first appears. Boxes are not often stacked horizontally and vertically, and even less commonly with the box facing forward, as Brown Thornton has done twice here. This drawing is as much a design as it is a still life. It works on both levels.

 Color

 Marker pen

 Observational, design

 Still life, objects

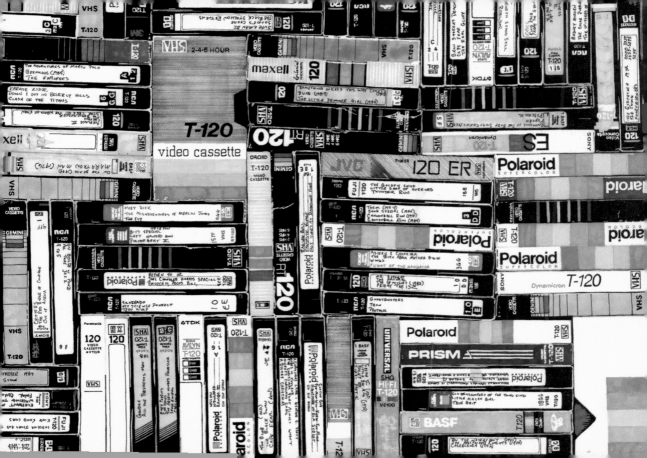

Color Accent

Kristen Donegan

This experimental drawing is full of ideas, most obviously its use of color. The off-center bird and the disk in the top left corner catch your eye because they are red. An eye-catching color in any context, but in this largely monochrome drawing, the red areas really stand out.

Another feature of this collage is geometric forms: a diamond cut from graph paper, the rectangle of an envelope window, the red dot-and-dash circle of the sun, and a sepia square composed of triangles. The geometric forms contribute to the success of the illustration as they provide a contrast to the natural subject matter. The inclusion of organic and inorganic items in a drawing often brings visual tension to an image. The most innovative feature is Donegan's use of the security print from inside the envelope to form part of the bird's plumage.

 Line, layers

 Found paper, colored ink, black ink

 Collage, experimental

 Birds, animals, nature

You can achieve the same washes of black watercolor or ink—which is what gives the blurriness of line here—by drawing on slightly damp paper or paper that is very absorbent.

See page 121 for an example of digital collage used to create a naturalistic effect.

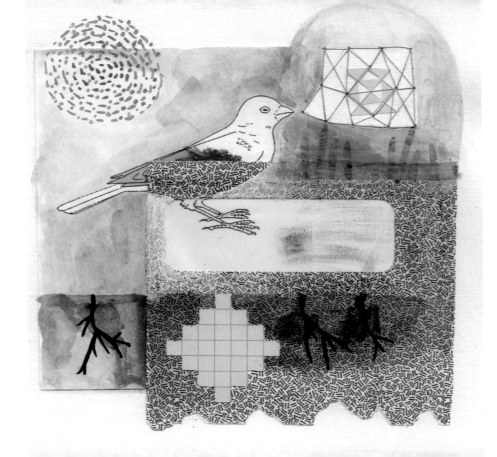

Unexpected Detail

**Leah Goren
and Kaye Blegvad**

Whenever two images are put together like this, your eyes flick between them as you try to make sense of the pairing, looking for similarities and differences. If you look at either of these drawings separately, you will see a loose symmetry to the floral design. A central stem is balanced on either side by flowers and fern leaves. The balance is not an exact mirroring, but the natural forms have been arranged carefully, as they would be in a floral display. These are not unusual compositional ideas. By using such a familiar form, Goren and Blegvad set us up for surprise with their hidden detail. Nestling in the foliage is a scattering of small faces, limbs, and single red eyes. These are much more noticeable on the paler background.

 Composition

 Colored ink, black ink, digital

 Observational, digital, imaginative

 Nature

These two drawings are too similar to have been drawn one at a time. They are exact digital copies. The original drawing was scanned and digitally manipulated to invert or reverse all of the colors except for the red.

Look for the hidden details in Chris Keegan's image on page 89.

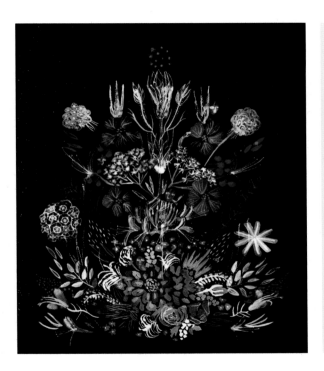

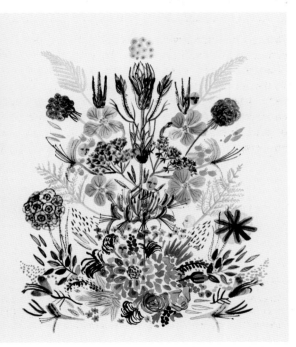

Complementary Colors

Pia Bramley

This breakfast scene is drawn with black ink and the lines are calligraphic in style—drawn with a brush, or the broad, chiseled tip of a pen—and characteristically applied in one stroke. The immediacy and natural flow of the black ink makes this drawing feel like something from a sketchbook. Bramley's addition of color to her black framework brings it to life. Her choice of red and green—complementary or opposite colors on the color wheel—makes the drawing more vibrant, and she has used a mix of these red and green inks to create the browns of the breakfast. Knowing how to mix colors to produce "new" ones can be very handy when you have minimal materials. The white spaces are important too: they balance the blocks of color. In leaving the plates and the cutlery white, along with the face, hands, and T-shirt of the woman, Bramley shows a knowing restraint.

 Color

 Colored ink, brush

 Observational

 Portrait, still life

For more information on complementary colors, see page 210.

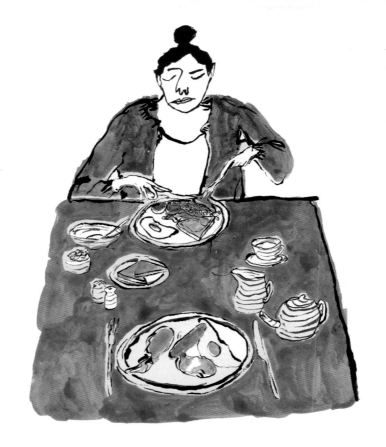

Composite Drawing

Timothy Hull

Hull has crammed much information into this composite image. Such a mass of objects is difficult to configure, but he has used glass display cases as a conceit, providing both a useful framework within which to set this multitude of ceramic forms, and a series of guides (the structural edges of the cases). He also plays with viewpoint here, changing it from one case to another: by varying the oval rims of the vases he allows us to see inside those on the bottom shelf, but not those on the upper shelves.

 Line, construction

 Gel pen

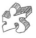 **Observational, perspective**

 Still life, repeat, pattern

The patterns are perhaps more important to this drawing than its technical execution. However, one wouldn't exist successfully without the other. The shadow play, gel-pen lines, stripes, dots, diagonals, and layers all add interest.

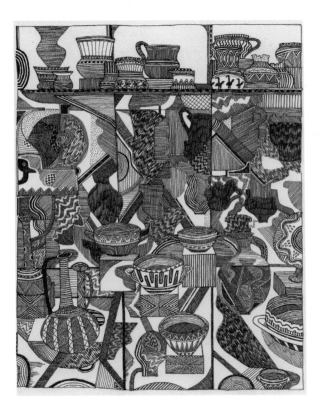

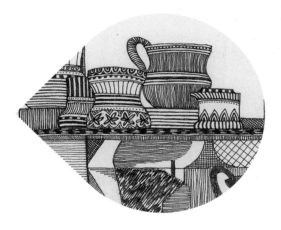

Colored Background

Jung Eun Park

Rather than relying on paper for the tone you want, try adding a wash of color. This will give you more control over it. The gentle ambience of this drawing is created by Park's subtlety of touch. The pinkish hue of the base paper provides a soft foundation for his delicate drawing. Park probably achieved the light tone by using a wash of watercolor for the base color, and has used a graphite pencil over this. Look at how he has drawn the strands of wool; how they undulate, form rhythms, but ultimately describe a form. He has achieved this because, although this is an imagined scene, it is based on observation. By adding green to the plant on the left, Park provides a complementary touch of color.

 Line, color

 Graphite pencil, watercolor

 Imaginative, conceptual, observational

 Landscape, nature

If you want to use wet materials such as watercolors or inks, you may need to stretch your paper to stop it from buckling and distorting.

See page 212 for how to stretch paper.

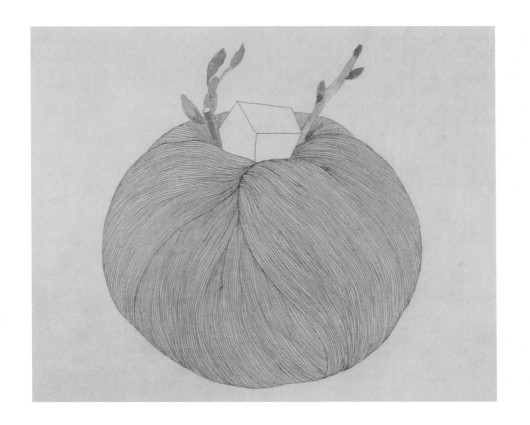

47

Digital Manipulation

Marina Molares

Molares created this digital collage using many varied parts and techniques, each one a useful idea you may want to try. Molares sourced the figure from an old book, probably a nineteenth-century volume of etchings or engravings. These are easy to find online or in used bookstores. She drew the boat with ink and pencil on colored paper and enlarged this (on a computer or photocopier) to make it appear granular and textured. Enlarging drawings in this way affects both the width and tone of the lines. Molares also digitized the hand-drawn curves and peaks of the waves, but in this case to make their gray lines smoother, and to repeat, flip, and layer them to form the body of water. Finally, she created the dotted halftone pattern for her landform and sky by applying a digital filter.

 Texture, layers

 Image editing software

 Digital, collage

 Seascape

You can apply filters using Photoshop, a smartphone, or a tablet app. You could also assemble your collage by hand, then scan or photocopy the final image to "flatten" it.

See pages 21, 27, 79, and 185 for varied examples using a similar approach.

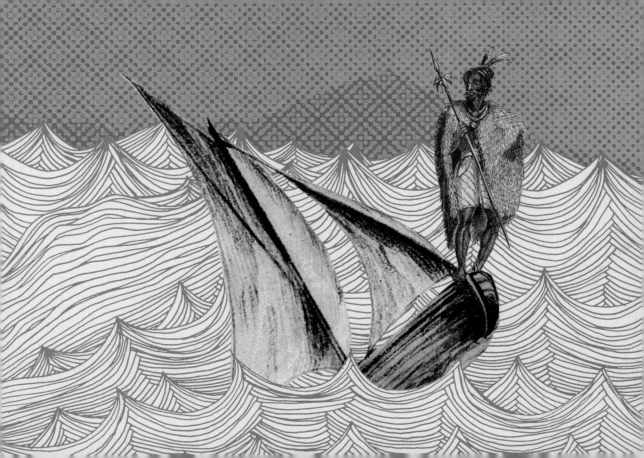

High Contrast

Lyvia Aylward-Davies

Aylward-Davies uses the high contrast between black ink and bright white paper to give the illusion of substance to this illustration. The solid fill in the windows contrasts, in shape and color, with the linear, white bricks of the piece, suggesting depth and solidity. Yet, by drawing the bricks in slightly mismatched sizes, and using a perspective that isn't quite "true," she has also given the sense of a slightly wobbly structure. Her doodle-like stylistic choices create a drawing that looks quite naive, yet describe this hefty, substantial structure well. By leaving the surround white, with no detail, she has kept her image stark. The castle stands sentinel, solid and constant in its own space on the page.

 Line

 Black ink

 Distortion, reference

 Architecture

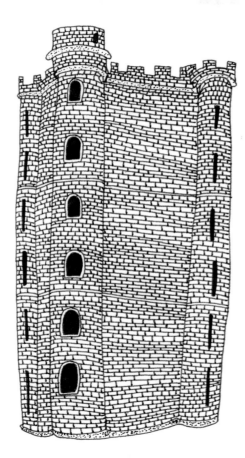

Contrasting Finishes

Carine Brancowitz

Some sophisticated drawings can be executed using the most ordinary drawing materials. Carine Brancowitz used a humble ball-point pen to create this super-detailed double portrait. Using these pens as intensely as this gives the surface of the paper an almost glossy finish. Here, it adds shine to the houseplant, the woman's hair, the magazine cover, and the man's boots. Other areas are filled in a much more linear fashion, but still with great attention to detail. Look at the way the checks of the man's shirt and the stripes and dots of the woman's clothes are rendered. Brancowitz has included a counterpoint to all of this attention to detail: areas of flat color, the bright red carpet being the most notable; and areas of no color in the large sections of plain white space. The key to this is knowing how much detail to include and how much to leave out.

Composition is the other major factor in the success of this drawing. The people take center stage, but with a slight weighting to the left of the frame. Their reclining forms give a horizontal emphasis to the drawing. Brancowitz balances this with the objects in the room, and the hint of an outside space through the partly opened curtain.

 Line, tone, color, composition

 Ball-point pen

 Observational, reference

 Portrait

The image on page 77 shows another bold use of ball-point pen.

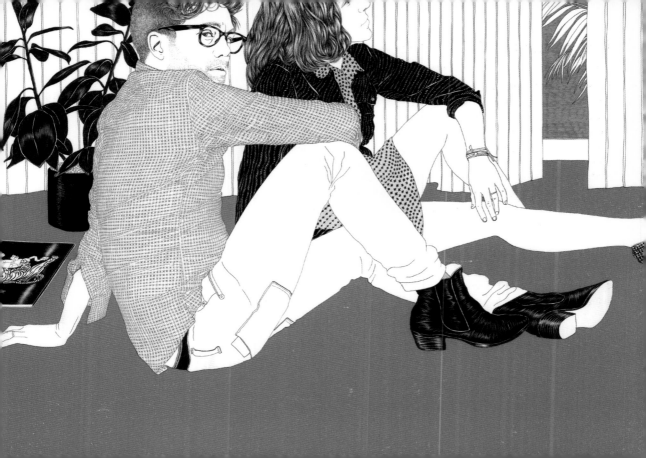

Damp Ground

Paolo Lim

Lim's landscape-format drawing uses a strong horizon line that is suggested by the meeting of the urbanscape with the water's edge. This draws the eye, and its placement signifies our viewpoint—somewhere close to the ground. Lim's drawing relies on a pre-prepared ground. He used watercolor paper with layers of pale washes. You can see a little paper distortion or rippling as a result of this, but not too much. To achieve the sunset effect of bleeding around the edges of color, Lim brushed the pure red and orange disks onto the surface while it was still damp.

 Format, layers

 Image editing software, watercolor

 Collage, digital

 Urbanscape

Lim created the urbanscape in this image by digitally layering images of buildings and cranes. You can create layered images using photocopy or Xerox transfer techniques—look online for examples of how to do this.

Background washes also feature in the sketches on pages 97 and 161.

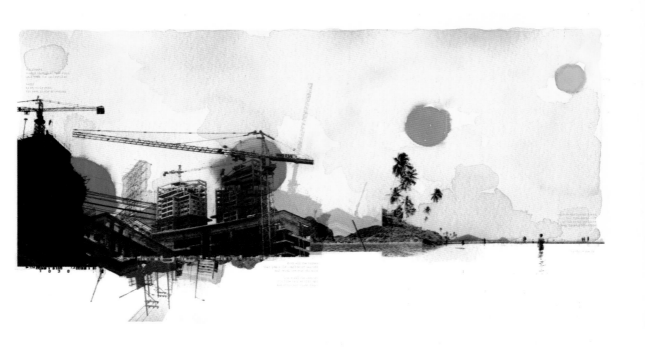

Animal Portraiture

Julia Pott

Pott uses typical portraiture techniques for this bear: a head-and-shoulders pose central to the frame, a slight tilt of the head creating a visually interesting asymmetry, and a touch of glint to the eyes. These bring more than a hint of personification to the bear and encourage us to empathize with it. They also allow us to add our own narrative to the drawing. Pott used good visual reference material—perhaps a series of photographs—to get an understanding of how to position her textured surface against the contours of the bear's body. She has used repeated dashes of gray and black lines to describe the fur, but left white spaces to act as shine or luster on it. The dashed lines are a study in tone too, and give the bear a three-dimensional shape on a two-dimensional surface. By adding watercolor in spots of red to the bear's nose and cheeks, and in colored stripes behind it, Pott has made her image even more eye-catching.

 Line, tone, composition

 Graphite pencil, watercolor

 Observational, reference

 Animals

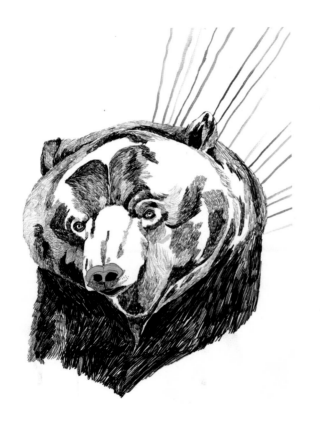

Character

Nayoun Kim

An illustrative style such as this takes time to develop, especially if you want to draw people—or figures reminiscent of the human form. The upward sweep of black hair is striking. Kim has scratched away the dense surface to suggest separate strands. Elsewhere, with the exception of the nose and the striped arms, she has used black as a thin, scratchy line. The character's personality and story come through Kim's detail: planes flying toward the character's heart and overhead; the blue tears and the wave. This simple form tells a whole story.

 Line, color

 Black ink, graphite pencil, oil pastel

 Imaginative

 Portrait

The skin tones of the body and face have been made with a malleable medium. Oil and chalk pastels are good for this—you can push them around on the paper with your fingertips to smudge and blend them.

See pages 167, 175, and 183 for other illustrative portraits.

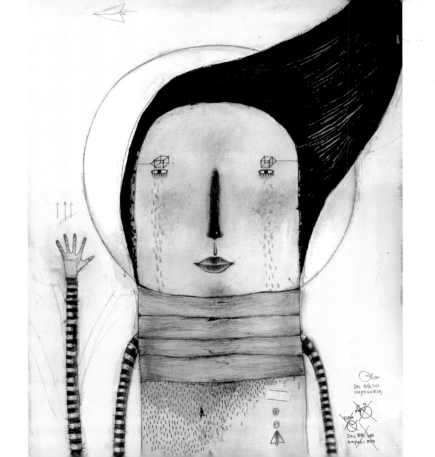

Digital Filters

Paula Mills

This decorative interpretation of a black feather has been "tidied up" digitally. It may seem odd to describe a drawing using vocabulary that suggests housework, but that's one of the things you can do with a computer. Mills homogenized the lines, making their constituent parts indistinguishable in terms of media application. She began the drawing with pen on paper, so the line initially varied in tone. By scanning this original line drawing and applying sharpening filters (in Photoshop or Illustrator), she made the lines crisper, the effect of which is to make the final drawing look like a print design. The fact that Mills has layered the bird and feather onto a textured cream fabric suggests that she wanted it to look like a section of printed fabric.

 Line, texture, layers

 Digital, fineliner

 Digital, design

 Still life, objects

Rosalind Monks uses intricate latticework detail in her image of an insect on page 141.

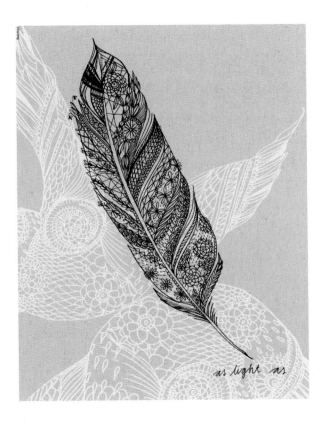

as light as

Layered Lines

Liam Stevens

This drawing is based on the idea of a landscape—one made up of a series of layers and lines that, laid down and built up in stages, suggest a receding series of hills and mountains. What is interesting about this illustration is that it has been drawn entirely with a ruler and black pen. Combining that approach with colored paper, a doodle becomes something more. Stevens has overlapped four layers of lines to produce crosshatching and create darker tones in the foreground than in the background. This tonal difference suggests distance within the drawing—great for a landscape. Last of all, in creating the sky with its sunlight rays fanning from behind mountains, he left a gap between the top two bands of lines to suggest snowy peaks.

Line, tone, composition

Fineliner, graphite pencil, colored paper

Observational

Landscape

You can try Stevens' technique of crosshatching and close lines to add tone to an image.

For more advice on tone, see page 200.

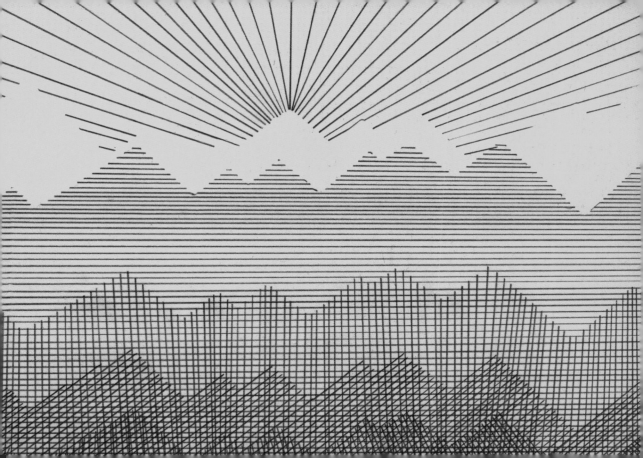

Dimension and Scale

Angela Dalinger

By numbering each building, and drawing them all using a neutral gray line, Dalinger identifies them to the viewer as one collection. She has strengthened this sense of unity by drawing each building viewed from the same angle, all with flat fronts, and all with their sides tapering diagonally. Such uniformity is characteristic of technical drawing, and the grid-like placement of architectural studies is devoid of people, but in many ways this is where the similarities end. The details Dalinger includes place her drawing in the imaginative realm—look at the patterns created in the tiled roofs; smoke from some of the chimneys; the shapes of the gardens, yards, and paths—and we're left in no doubt that people live here. The buildings seem to be the same size, yet they include a two-story house, a church, and a three-story apartment block. The intriguing result draws you in.

Line, composition

Graphite pencil

Observational, imaginative

Architecture

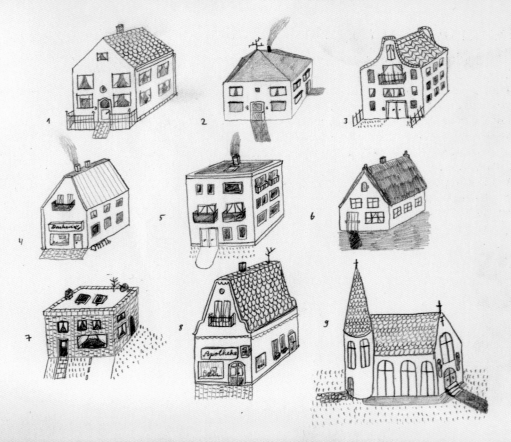

Directing Gaze

Sophie Leblanc

This drawing is full of ideas and a sense of playfulness. Leblanc first directs our gaze to the figure by giving her a thick black outline and mapping the other objects out in lighter pencil. She then directs our eyes through the woman's gaze. She isn't looking at the other objects in the drawing, but focusing beyond them, as is the collaged eagle on her shoulder. Our eyes follow. Leblanc uses red as a unifying element in the drawing. It connects the collaged fabric stripes; the letters i, r, g, and h with the c of the image's title; the rouge of the girl's cheek; and the red-dotted chicken skin. The same red of the dripping blood colors the shoes. And this all brings our eye back to the central figure.

 Line, color

 Sketchbook, black ink, graphite pencil, colored ink

 Observational, collage

 Portrait, text

For other examples of using a sketchbook to record ideas, see the images on pages 31, 73, 123, and 177.

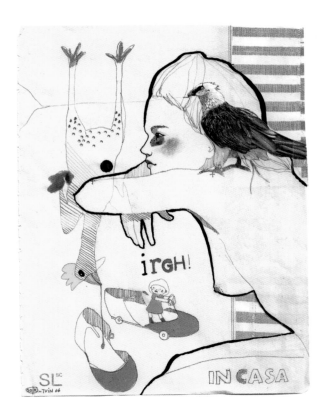

Drawing with Paper

Kaye Blegvad

By repeating these simple and spontaneous cat heads, and giving each one unique features, Kaye Blegvad has created a charming group of feline faces. The starting point for this collage was Blegvad's range of papers. Her cat-head motif is basically the same form, repeated eight times. She made the outline drawing with a pair of scissors, without guidelines, giving these first shapes a natural immediacy. She added the black-and-white facial features with a similar flourish. Such lively doodles on the collage base add to the lighthearted touch. Drawing does not have to be a serious undertaking. You can be ambitious about what you want to achieve and try out things that may conjure up a smile.

 Color, layers

 Colored paper

 Collage

 Animals

It is well worth collecting papers. Think of them as you would a box of colored pencils.

The image on page 171 also uses found papers, but with minimal drawn detail.

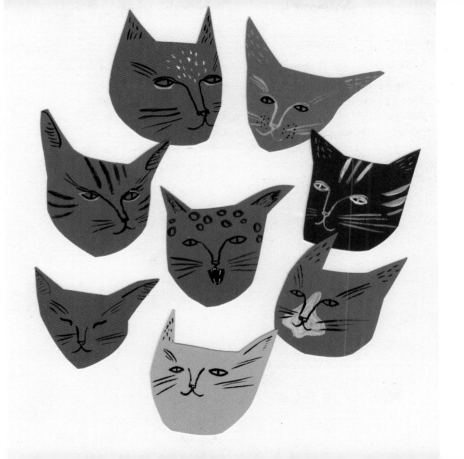

Felt-Tip Marks

Frida Stenmark

Stenmark's familiarity with these objects—some of her drawing paraphernalia—has ensured an ease and flow in the quality of her line. You can see that she did no preparatory pencil work but has completed this entire drawing with felt-tip pens. The pen has soaked into the paper surface at certain points. This occurs when a pen is still on the paper, perhaps while the artist looks at the subject matter before moving on. It is clear that Stenmark has spent as much time looking as drawing. This is a good habit to acquire.

 Line, color

 Felt-tip pen

 Observational

 Still life

It is interesting to see how others organize their drawing materials, and what it is they use. Stenmark's desk is ordered: pens in a pot, grouped brushes, dip pens and pencils together, and inks and masking fluid at the front. Drawing is always going to be easier if your materials are well ordered and at hand, and you enjoy looking at how they're arranged.

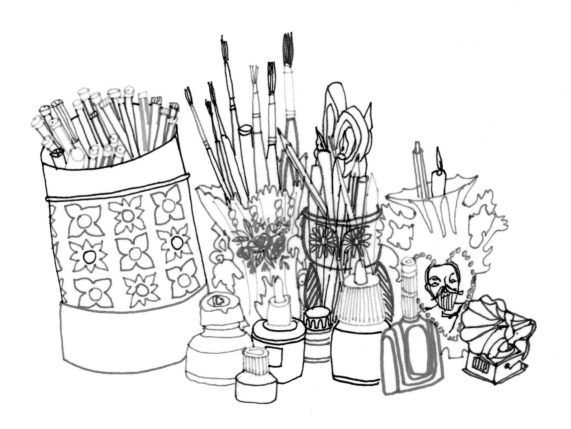

71

Sketchbooking

<div align="right">Sophie Leblanc</div>

It's not easy to get to the stage where your sketchbook flows with an easy visual confidence. The trick is to know what sustains your curiosity, and to keep on practicing. These five pages from Leblanc's sketchbook give a clear sense of the subject matter she revisits regularly and of her media of choice. The human form, fashion, and nature regularly appear; color, pattern, and text are used throughout; pencil and felt-tip pen (easy to carry around) are predominant. Leblanc has sketched some drawings on loose paper and added them to the sketchbook.

 Color, line

 Fineliner, graphite pencil, felt-tip pen, ball-point pen, gouache, colored ink, black ink, sketchbook

 Observational, schematic, collage

 Portrait, text, nature

Carry a sketchbook with you whenever you can, and make sure you have drawing materials too.

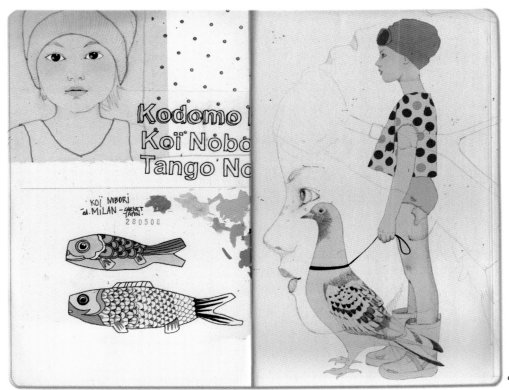

Kodomo
Koï Nobo
Tango No

KOÏ NIBORI
ed. MILAN – CARNET
JAPON.
280508

continued ▶

à dessiner
(W. rue BCN) → jeune ho
① avec 1 ra
 (+couvertes

 → série
TROUVER ∿

recherches
- annie Hall

dessiner profils black.

∗Hélène LeBlanc
ZOU ZOU
carnet de quotidien

Rayures ←

PHOTOGRAPHES MODE

PERROQUET / OISEAU
à la place du ballon
 ✗

ESSAYER
VERSION CHEV.
VERSION FOULARD → motifs
 Olzou ✗
 ✗

que extiende las membranas de
sus patas cuando salta.

grenouille
volante

Las expansiones membranosas
unidas a las costillas movibles
de los lagartas voladores le
permiten planear largas
distancias.

Pluie de grenouilles
ROSES.

dans le Glo
grenouilles albinos.

75

Graphic Device

Artists often turn a mundane, overlooked item into something extraordinary. Brancowitz has used a powerful graphic device—the combination of black, red, and white—to render a humble box of matches. The stark contrast between the black and white, and the counterpoint flare of red, suit the subject matter: a flaming match burning to charcoal. The angle at which Brancowitz has drawn the matchbox allows us to see the detail of its design—both its top label, and the textured strike panel on the side. There are very few tones and areas of shading, just a hint on the burnt part of the matches and a highlight in the red tops of the unstruck matches. There are no shadows under, in, or around the box, yet it still appears to sit on a suggested surface.

 Line, color

 Ball-point pen

 Observational

 Still life

Carine Brancowitz uses ball-point pen to create blocks of color in her image on page 53.

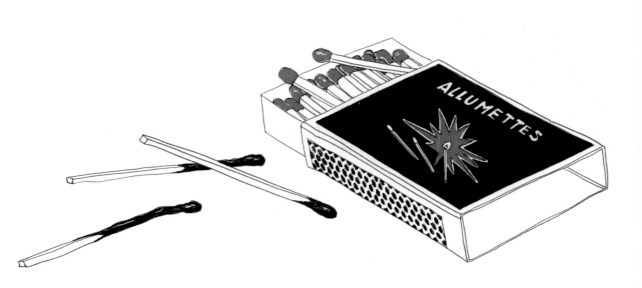

Found Images

Valerie Roybal

The background, and base, of this collage is an engraving of a Victorian street scene. Roybal was attracted by the narrative of the print. Collect images that catch your eye, as they can be a great prompt for a drawing. Roybal's image is made up entirely of found items, including other printed engravings along with modern colored papers, some of which are also printed or painted. The drawing is rendered not with a pen or pencil but with an X-ACTO knife. Roybal has cleverly layered her collage to create an almost theatrical scene. She has created a frame of color to provide a foreground, and suggest the present, with a black-and-white background to suggest depth, not only of dimension but also of time.

 Composition, layers

 Found paper, X-ACTO knife

 Collage, conceptual

 Urbanscape, people

You can see other examples of drawing with an X-ACTO knife on pages 115, 135, 151, and 183; and different executions of digital collage on pages 21, 27, and 49.

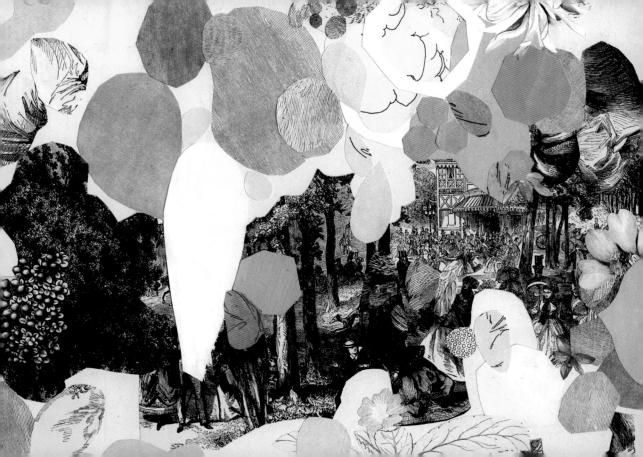

Graph Paper Ground

Paolo Lim

Paper selection can dictate the way a drawing develops. A gridded or graph paper has clearly influenced this example, prompting where to place the next mark, and aiding Lim with his placement of the overall drawing. Lim used a black pen to draw lines that crisscross the vertical and horizontal axes of the graph paper. This lends a mathematical sensibility to the drawing, without its doodle-like quality being lost. The "join the dot" meandering of Lim's pen forms a waterfall-like pattern.

Lim uses shading to suggest the sun casting a path of light over a body of water: those darker triangles, in-filled with parallel lines, are not merely pattern doodles; they enable one pen, making a consistent mark, to describe light and shadow. Lim's final touch is in the triangular details of the origami birds flying above the horizon. They fly below a sun that is an inverted version of the water—a black form with pale lines rather than the other way around.

 Line, tone

 Graph paper, fineliner

 Imaginative, doodle

 Seascape

A pre-marked surface such as graph paper can also help you to compose a drawing by showing where a border might go.

For other illustrations using a graph paper ground, see pages 93 and 133.

Flat-Color Portraits

David Gomez Maestre

Gomez Maestre's unusual portraits combine colorful masks and an unexpected choice of models. The origin of the portraits—posed studio photographs or magazine pages—is clear. The subjects look straight into the camera and hold their heads in such a way that the poses feel directed. Gomez Maestre's use of color is playful. We can see the felt-tip marks, but these portraits have an essentially two-dimensional surface. He uses areas of flat color to portray the underlying bone structure. He includes a hint of highlight only in the eyes—and that white glint makes all the difference.

 Color

 Felt-tip pen, ball-point pen

 Imaginative, design

 Portrait

Gomez Maestre believes it is important to portray sitters without losing the essence of who they are. It is a challenge to make a simple black outline of a face and retain the individual's identity without the tones you find in a photograph. Try this technique by finding a photograph of someone you know or recognize and tracing the image using the fewest lines possible to portray their likeness successfully.

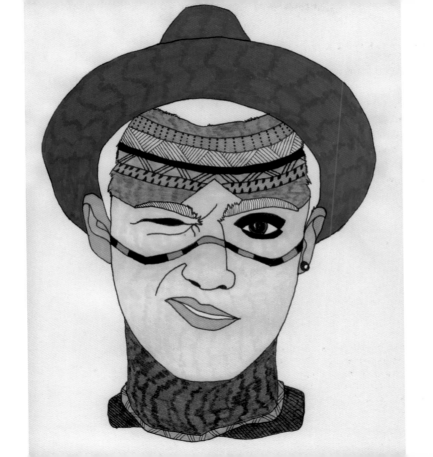

continued ▶

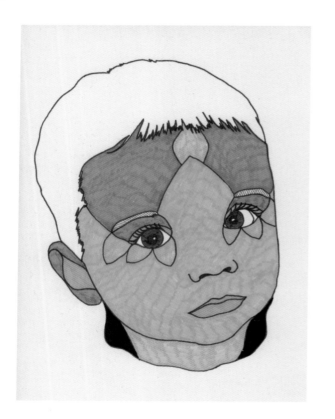

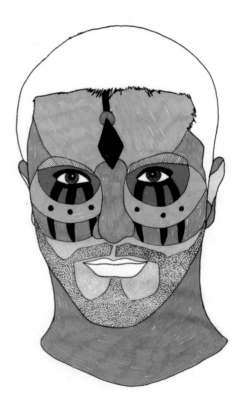

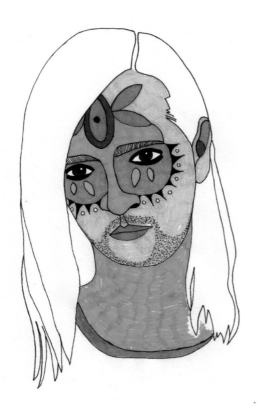

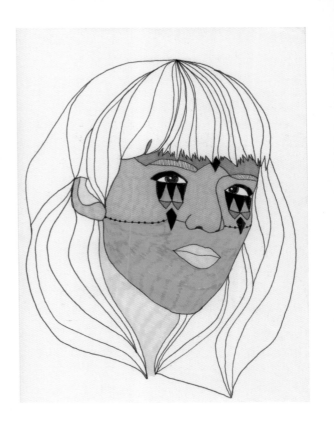

Subdued Color

Emanuele Kabu

Our eyes are drawn to brightly colored, exuberant images. But subdued images can contain much to hold our attention—we just need to look a little closer. Many interesting techniques are at play in this restrained drawing, dominated by grays. The structure in the middle is drawn with dark gray lines rather than black. Black can be very dominant, so it is good to consider paler shades, especially where you want a more subtle finish.

Kabu has created a sense of uncertainty in this drawing. His imperfect ruled lines, with their slight flecking, make the framework appear unsteady, and his band of mottled pale blue and gray along the lower edge, in addition to providing texture, heightens this sense of uncertainty as it isn't clear whether this represents solid or liquid.

 Line, texture, tone

 Colored ink, watercolor, wax resist

 Imaginative, conceptual

 Architecture

This mottled-stripe effect can be achieved in various ways. You can apply a base color (here it is pale blue) and add a resist or mask over the top to prevent additional colors reaching these areas. This could be white wax (from a crayon or a candle) or masking fluid. Finally, add your second color (here it is a gray wash).

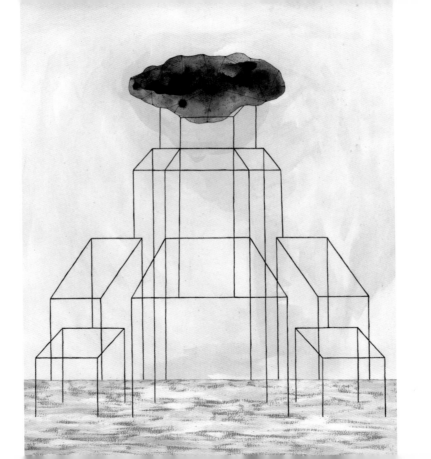

Ground-Level View

<div align="right">

Chris Keegan

</div>

Ground-level views provide an unusual vantage point. Seen from this perspective, grasses and plants that usually appear small are not insignificant at all. Keegan had a definite idea in mind for this drawing and selected reference images with a strong silhouette. A cut line can be as significant in a drawing as one made with a pencil or pen. Here it is made digitally. You can take a reference photograph using a fish-eye lens to get this effect, or digitally manipulate a standard photograph. In essence this is a layered digital collage, constructed from four levels of color. The beauty of Keegan's piece lies in how he has overlapped these layers with semi-translucent areas, and added a hidden twist—look closely for the tiny people and an airplane dwarfed by the insect life.

 Color, layers

 Digital, image editing software

 Digital, collage

 Landscape, nature

You can do something similar by cutting silhouettes from magazine or other images, collaging them, then tracing with a pen or pencil, adding flat color to the new shapes you create. Various fish-eye apps for smartphones and tablets are available. Use these to "filter" your photographs, print them out, cut and paste them into new forms, and generate new ideas.

Highlights and Tones

Hisanori Yoshida

The dream-like quality of this drawing is enhanced by its lack of a horizon line, which makes it difficult to get a real sense of perspective and leaves a question mark over whether this is a land- or a skyscape. The dark, chocolatey brown-black gives the scene a warm feel that wouldn't be there had Yoshida chosen to use black instead. He has built up the drawing with layers of ink, using a brush, to bring four different tones into play—you can see them in the light aura of the candles and sky lanterns—and he has added white highlights to finish. Yoshida's highlights make the candle flames luminous and the snowflakes shine with reflected light. The bird doesn't need to be luminous: its purpose is to add drama and scale.

 Tone, layers

 Colored ink

 Monochrome

 Landscape, skyscape

To try this effect, apply the palest tones first, then add the others one by one, moving from light to dark. There is one exception to this rule—add the white highlights last.

For other interesting examples of "light in darkness," see pages 127, 145, and 208.

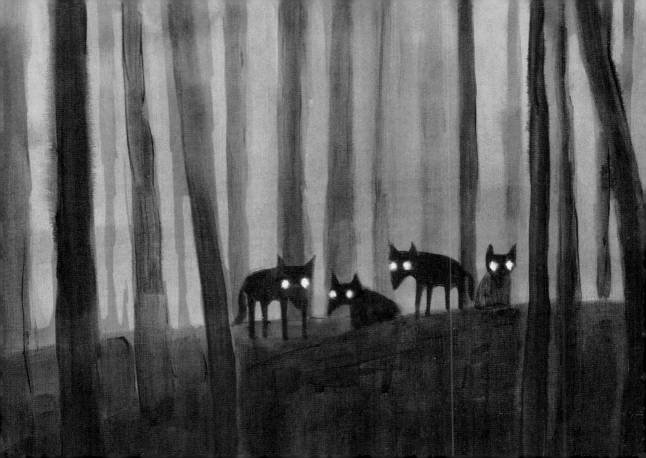

Grid Paper

Valero Doval

This drawing has a graphic sensibility. Its clean lines, balanced symmetry, and harmonious layout give it the look of a logo. Doval's stylized rain cloud also has a Japanese feel thanks to the tightly constructed curved patterns used to make up the body of the cloud, and the characters that symbolize the rain. The squares of the grid paper give the drawing a sense of scale. The original is quite small, making us appreciate the control, rhythm, and pace of the curves that are formed from the squares. They interlock to give a real sense of a repeated, and inverted, pattern. Doval continues the fine control of this drawing with careful collaging of the rain. Its precise placement parallel with the grid lines completes this simple, yet quietly sophisticated drawing.

 Color, line, composition

 Marker pen, collage, paper

 Abstract

 Pattern, repeat, text

You can allow your paper to inspire you. Doval's red pen works well with the blue lines here. If your paper encourages you to color parts in, or to doodle, let it happen.

The images on pages 81 and 133 also use graph paper as a contrast to curved patterns.

スタンフォード大学 客員教授 野口悠紀雄 定価

大人のための算数

93

Internal Frame

Sara Landeta

Landeta has given her bear an outfit and used this as an illustrative space: a frame within a frame, or drawing on a drawing. This clever concept has allowed her to contrast a riot of pattern and color with plain black fur; an imaginary landscape with an animal portrait; exuberance with restraint. She has allowed the rough texture of the paper to show through the fur only, highlighting the difference in texture between fabric and fur. There is no true sense of perspective, but Landeta still gives us the sense of an inhabited landscape.

 Color, texture

 Colored pencil

 Imaginative, conceptual

 Animals, landscape

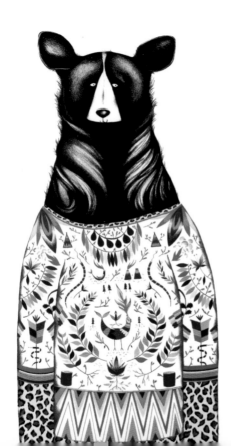
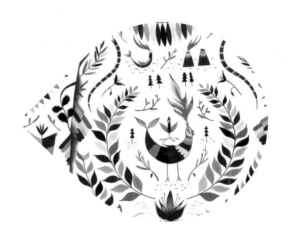

Layered Color

Betsy Walton

If you want to build up layers of color, one option is to begin with a stain or texture. Walton used this approach for her bathing beauties. She obviously didn't complete it in one sitting: she has drawn, blocked out, and redrawn. Choose a strong enough paper to withstand this treatment; a thick card would work perfectly.

Walton's scene is dominated by a pink-tinted wash of paint or ink that acts as water and sky, and she has picked out the swimmers' outlines, the boardwalk, and the beach area with pencil line drawn on the wash. You can see some faint vegetation where the boardwalk is. This partially erased outline gives the effect of something submerged. She has used dominant tones of black (applied with a brush) and red (applied with a pen) to describe other plants and complete the watery scene. The saturated colors and full tones of red and black add a tonal balance and a multiple focus point to the drawing. Without them this bathing scene might seem too wishy-washy and much less robust.

 Line, layers

 Paint, paper, colored ink, graphite pencil

 Imaginative, experimental

 People, seascape

You can use thin plywood as a surface for a layered drawing. Prime it with a thin coat of white emulsion paint to stop wet drawing media, such as ink, from soaking into the surface and settling where you don't want it to, such as along the grain of the wood.

Background washes are also integral to the images on pages 55 and 161.

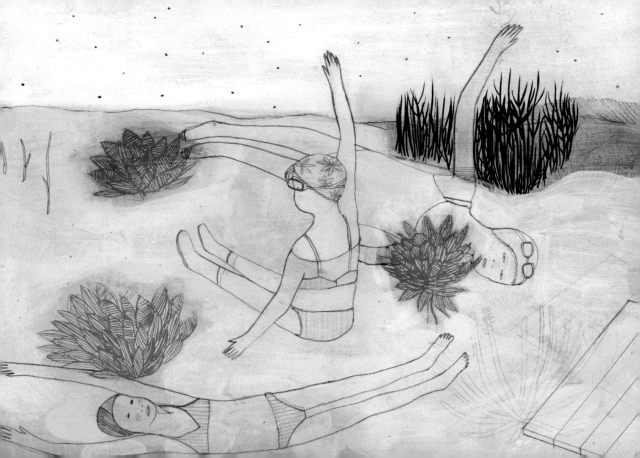

Mark-Making Tools

Dale Wylie

We can see how this monochrome monoprint has been rendered, as this method leaves clues. For monoprinting you roll ink down on a flat, horizontal surface—a non-absorbent tabletop or piece of glass—place paper over the ink, and draw the image onto the "wrong" side of the paper, thus transferring the ink to the "right" side. You can trace or photocopy the image onto the wrong side of the paper, or draw it freehand.

Wylie produced tones by using his fingers, or blunt implements, to "push" the design onto the right side of the paper. He scraped on the cloud forms with a flat edge—perhaps a ruler—and made the hills with his fingertips, using an even pressure to gently rub them on. The land between the hill and the town he dabbed on—his fingerprints are visible in it—while for the line and finer details he used a blunt pencil, or an inkless ball-point pen. These "accidental" marks add to the feel of the drawing.

 Line, scale, composition

 Black ink

 Narrative, experimental

 Landscape, people, urbanscape

Remember that whatever transfer method you use, the end product will be reversed. This is particularly important if your drawing features text. Printing ink tends to work best, but you can use acrylic or oil paint. Try using a sheet of carbon paper for a similar effect.

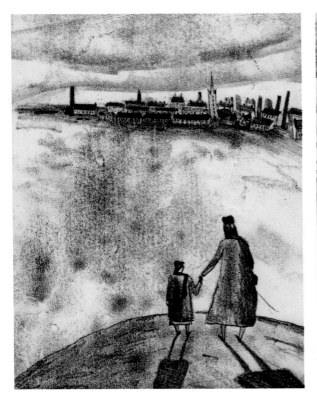

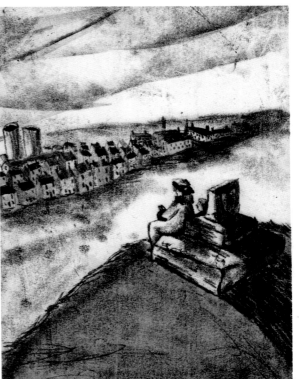

Including Text

Kelly Lasserre

Inspiration for a drawing can be found anywhere—even in the fridge. Finding inspiration in your home is an approach to consider. For her artist's palette of *Spreads in My Fridge*, Lasserre organized her "swatches" in rows, and included text labels to give a sense of observation and order. Her humorous touch of adding two splashes of strawberry preserves results in a drawing with the immediacy of a palette in use.

It is surprisingly difficult to include text that works well within a drawing. Lasserre used a sharp black pencil and included quirks in the text (a random capital "Q" mid-word, "y" sitting above the line, and an individualistic "w"), to give it a hand-drawn touch.

 Color

 Watercolor, colored ink, oil pastel, gouache, colored pencil

 Observational

 Still life, text, objects

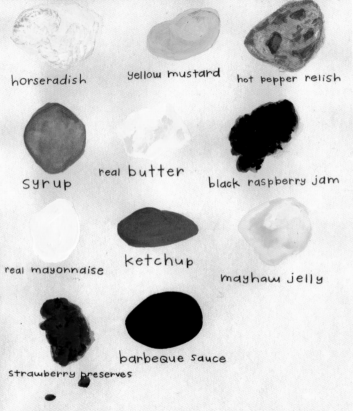

horseradish

yellow mustard

hot pepper relish

syrup

real butter

black raspberry jam

real mayonnaise

ketchup

mayhaw jelly

strawberry preserves

barbeque sauce

SPREADS IN MY FRIDGE

Light and Shade

Donny Nguyen

An informal portrait can be turned into a study of light and shade. Nguyen found someone relaxed, lying down, and therefore still, to act as a model. The shadows cast by the frame and tinted lenses of the sunglasses show that the source of light lay at an angle above the model's head. The result is a study of the way light falls, of highlight and lowlight, and of shading. Nguyen built up his black ball-point pen in stages, mapping out fine lines as an outline, the pen barely tickling the paper's surface. He then built up areas of shading in series of crosshatched or diagonal lines. Only in deep shadow, or behind the tinted shades, has he used any really dark black tones. What makes this portrait more than simply a technically good drawing is that pair of sunglasses! The red lines on the plastic frames add a standout, attention-grabbing note.

 Line, shading

 Ball-point pen, sketchbook

 Observational

 Portrait

See page 167 for a similar effect using a different technique, and page 189 for another example of Nguyen's portrait work.

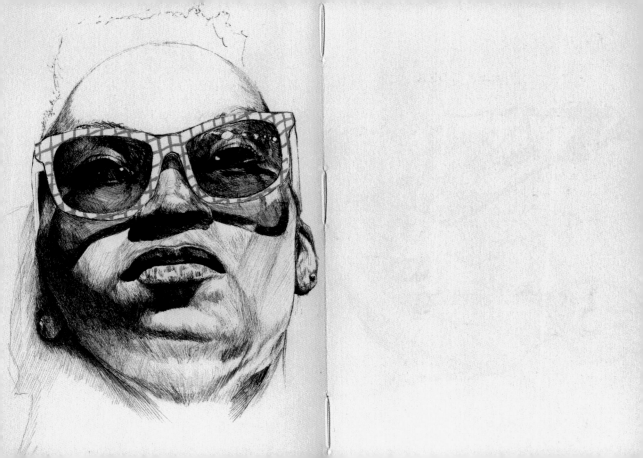

Line Drawing

Jean-Charles Frémont

Focusing on one object, and drawing it with great attention to detail, can be rewarding. At first glance this is a simple line drawing. It is detailed, but the lines are not overly clinical or "tight." Frémont has drawn them freehand; they have a characteristic fluidity and naturalness.

The clean line a pen gives can be used in different ways. It is not the best tool for allowing variations in tone—shading—but in this drawing Frémont is not concerned with that; he is more interested in describing an item in a clear and effective way. The detail in this drawing is a large part of its attraction. The writing and the tiny crosses of the construction fittings are lovingly rendered.

 Line, scale

 Fineliner

 Observational, design

 Still life, objects

You can add much more detail to a drawing, and make the black areas appear more intense, if you render it at a larger scale and then reduce it in size digitally.

Collage and Scale

<div style="text-align: right">**Lisa Naylor**</div>

This image is a good example of anthropomorphism, which is strongly associated with the art of storytelling. The basis is a found image of two rabbits. Naylor is not concerned with disguising this; she has simply painted over any unnecessary information and drawn directly onto the image with black pen to give the rabbits human characteristics: glasses, a mustache, and a hair ribbon.

Naylor also plays with scale in this image, placing small human bodies under the giant rabbit heads, but enables us to read each character as one being rather than a composite of two collaged parts by outlining them with black pen.

 Line, color

 Image editing software, fineliner

 Collage, digital

 Animals

You can disguise a found image—or make its origins less obvious—by manipulating it digitally and layering it.

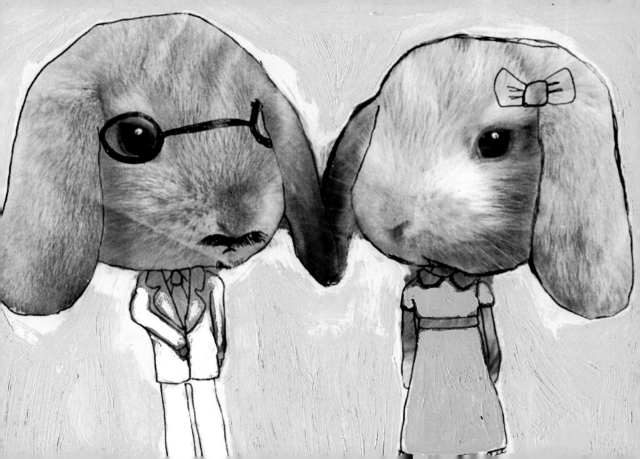

Negative Space

Stephanie Kubo

Kubo has combined restraint and exuberance to bring this patterned panel to life. She drew it using the most basic materials—felt-tip pens, a compass, and a ruler—and a limited color palette. The bright red and pink make her design zing, and she has used black to bring the image together. Organic forms are framed by hoops, but also spill out of them, and Kubo has added geometric shapes as a counterpoint to the pattern. Note her use of negative space—the white areas help to balance the whole.

 Line, color, format

 Sketchbook, felt-tip pen, ruler, compass

 Doodle

 Pattern

Something about this work suggests a doodle-like approach. You can see examples of less "formalized" doodling on pages 31, 35, 81, 93, 133, 147, 149, 153, 169, and 195.

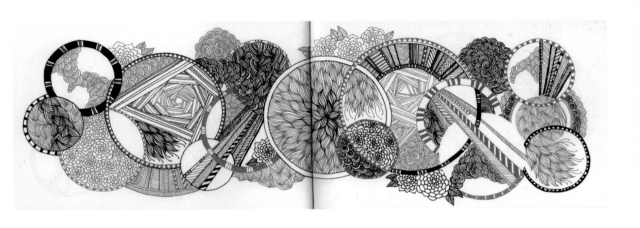

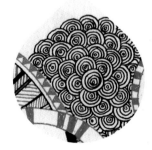

Suggesting Time

Jeffrey Decoster

This is a clever mix of digital manipulation and hand-rendered work. Decoster makes the female figure in the center dominate this drawing by applying solid color to her. With the exception of the smaller, black silhouette form, everyone else is drawn in outline only, allowing the tinted background to show through. He shows that this is a composite scene, that it doesn't represent a single point in time, by drawing his figures without proportional sense—they're either too big or too small in relation to one another—and drawing their shadows at multiple angles. The fact that he changes his style of drawing for different figures (look at the distorted scale of the man on the bike and the clean lines of some figures compared with others) further emphasizes this.

 Line, layers

 Felt-tip pen, digital

 Monochrome, reference

 Urbanscape, people

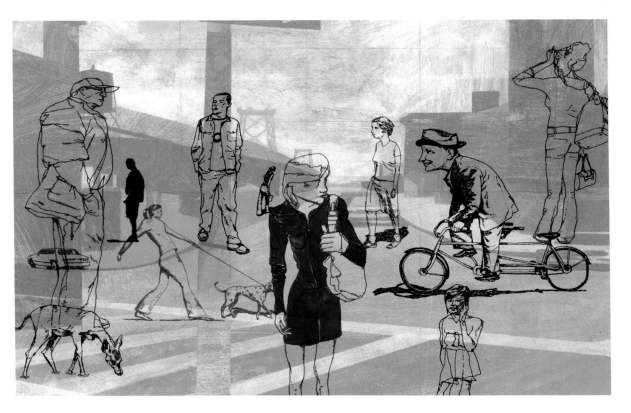

Geometric Structure

Isaac Tobin

Tobin has used geometric structure and shapes within shapes to create this lighthearted, playful image. The square format balances the forms within its frame, the centrally placed rectangular suitcase acts as a border for a circle, and a collage—which includes masking tape—offsets graph paper with a musical score in this harmonious composition.

Tobin also uses color, within a framework of dark gray lines, in a very balanced way. The warm tones of the aged music sheet sit well with the brighter yellows and gold in the drawing. The suitcase, in a partly translucent banana yellow, is bordered on the right by a swath of gold ink, a drawing medium that dries to a more solid finish. This is a truly mixed-media piece.

 Color, layers, format

 Found paper, oil pastel, colored ink, gouache, crayons

 Collage

 Still life, objects

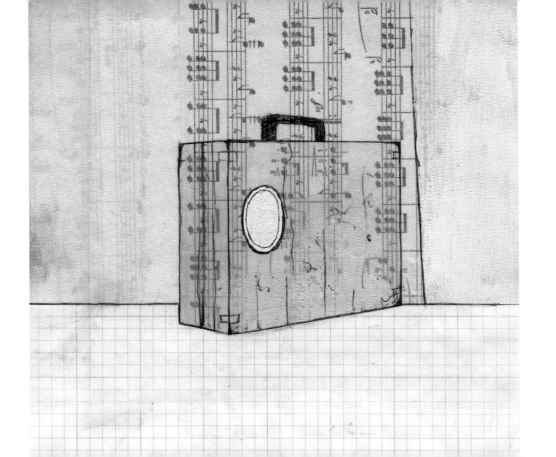

113

Paper Cut

Bovey Lee

We think of a drawing as being a line, or lines, made on paper. For this hanging gown, Lee used a craft knife to cut negative shapes from the paper, making the image emerge. It takes both a great deal of skill and much planning to create a work like this. Lee has observed the wire fence—an intricate structure with two layers—minutely. Working from a photograph helps you to achieve such precision of patterning. Look at the diagonal piece of barbed wire in the top left-hand corner and the distortion in the drawing's perspective. The gown on the fence acts as a counterpoint to the intricate diamond patterning around it. There are significantly fewer cuts here—it is mostly white paper.

Lee's illustration succeeds because of the balance between intricacy and simplicity. It also works because the result is photographed against a mid-range gray paper onto which it casts subtle shadows. This gives the drawing, cut from one, flat, sheet of paper, a three-dimensional feel.

 Line

 X-ACTO knife

 Three-dimensional, narrative

 Still life

See page 135 for a very different example of a paper-cut illustration.

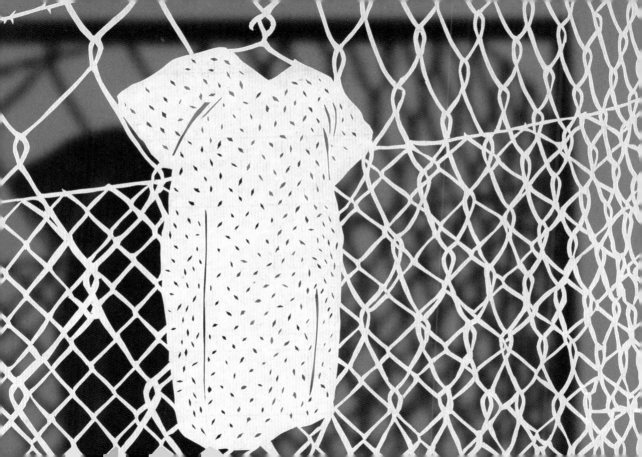

Painted Drawing

It is good to study artwork at the boundaries of disciplines. This allows you to question the possibilities of different media and come up with fresh ideas. This painted image sits on the edge of what is termed drawing. Davis used a strong palette of acrylic paints from a small section of the color wheel. The warm shades show an analogous color palette, with the colors coming to the near left and right of each other on the color wheel. What brings this work into the arena of drawing is Davis' pencil and charcoal work on top of the paint. By adding a fine graphite line, she has defined the hairline, face, and neck. Through dark tones of charcoal, she has given depth to the eyes, nose, and mouth; a black would be too harsh here. She has also stripped back parts of the face, gently sanding them to reveal the color beneath in order to suggest the texture and mottled nature of skin and to define the nose and one eyebrow.

 Color, layers

 Graphite pencil, acrylic paint, charcoal

 Experimental

 Portrait

You can achieve a similar effect using gouache paint.

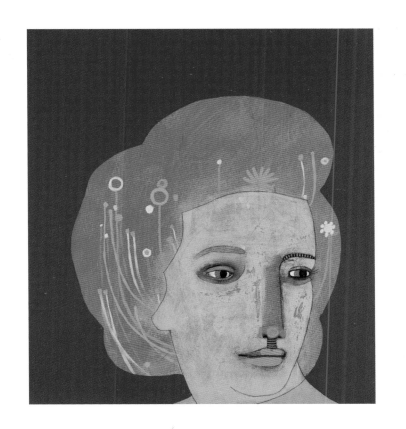

Paper Textures

Diego Naguel

Naguel used an assortment of papers to construct a panda's habitat, including three wallpapers and the reverse of a printed receipt, carefully selected for their color range, scale of pattern, and motif. He suggests a grassy foreground with a green, flecked paper, and the gently undulating land behind with a floral print. Naguel drew the panda directly onto the third layer of patterned paper so that the larger pink flower motifs become part of the animal. The color and texture of these papers are key to the drawing's success. Gentle tones of green, pink, and cream sit well with an essentially black-and-white creature. The black-and-white pencil crayon and white pen don't cover the surface entirely, but allow the underlying color to show through. In this way, paper texture becomes panda fur. The layers of ripped, torn, and crumpled-edge papers add an illusion of depth to the drawing, producing a shallow relief.

 Layers, color

 Found paper, crayons

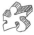 **Collage, reference**

 Animals

As a finishing touch, Naguel has added a decal letter—a "P" for "Panda."

See page 151 for a very different result from this layering technique.

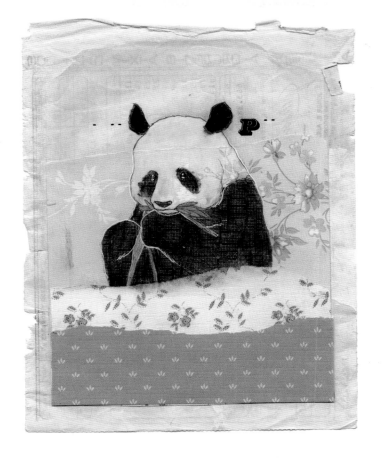

119

Multimedia Image

Sandra Dieckmann

Dieckmann used a number of media to create this complex design. It involves many components, and many layers, which she has brought together through the digital "flattening" of the image, through repeating the shape of the collaged clouds, and enhancing the collaged mountains with pencil. She drew the orange-red disk of the sun in felt-tip pen, working textured lines to add a visual interest you can't create with flat color.

 Tone, color, scale, layers

 Found paper, felt-tip pen, graphite pencil, ball-point pen, digital

 Collage, digital, narrative

 Birds, landscape

You can achieve the effect in these clouds using pattern repeats from the insides of business envelopes, which often feature wonderful patterns.

The image on page 39 uses digital collage to create a more abstract drawing.

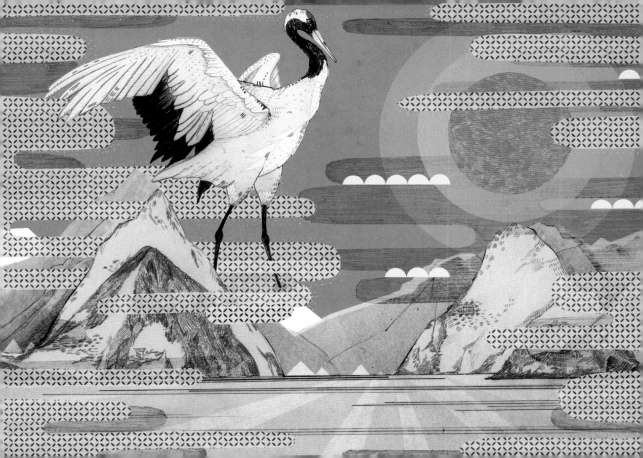

People Watching

<div align="right">Steve Wilkin</div>

We all "people-watch" to some degree. Here that scrutiny is used to great effect in a series of sketchbook drawings. This sequence is a selection from the many completed on Wilkin's commute to work. He observed all of these people on a train in various states of wakefulness and awareness. Drawing in a place to which you are accustomed means you can predict certain timings and rhythms. Knowing this daily journey—its duration, its stops and starts, who gets on, and at which station—means you can be prepared. A certain amount of stealth is required: not everyone likes to be the focus of attention, so locating yourself in an advantageous and comfortable position is key. These seated individuals are all drawn in profile. The pencil line reveals how quickly some of these furtive portraits had to be done: some are minimal scribbles while others show increasing amounts of detail. Wilkin used nothing other than pencil and sketchbook for these drawings. He achieved the range of line and tone needed through applying varying degrees of pressure.

 Line, tone

 Graphite pencil, sketchbook

 Observational

 Portrait

You need the right equipment for this sort of drawing: a pencil of the right softness (you may want to consider a propelling pencil, so there's no sharpening needed), and a small, unobtrusive sketchbook.

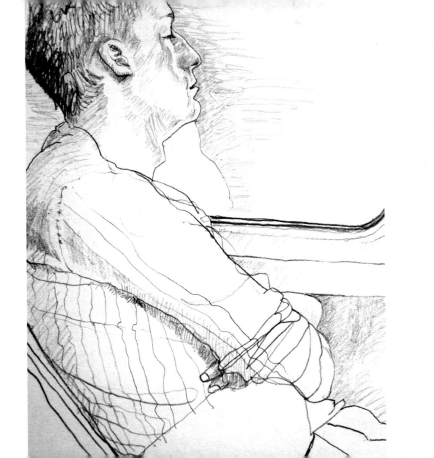

continued ▶

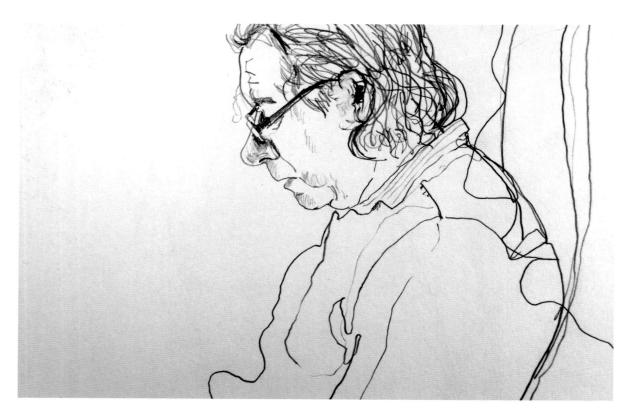

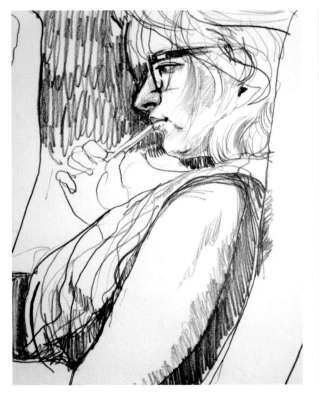
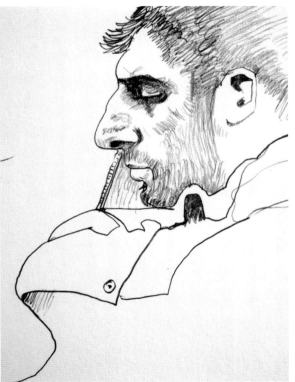

Reverse Drawing

Hisanori Yoshida

We tend to think of drawing as adding materials to a surface. The usual order is to build up an image, layer by layer, area by area. Here the reverse is true. Yoshida employs an unusual technique for this monochrome drawing: removing areas of his ink wash to reveal the white of the paper beneath. This suits the dreamlike narrative well. There are various ways to make a reverse drawing and they all take a little practice to perfect. One of the simplest ways is to draw onto your pre-prepared background or a colored paper (tissue papers usually work well) with an extremely diluted bleach solution, using a brush or a dip pen.

Yoshida sets a nighttime scene by placing twinkling stars that show through the forest canopy, adding highlights cast by an unseen moon, and achieving spatial depth by including detailed flowers in the foreground.

 Tone, layers

 Colored ink, watercolor, bleach

 Imaginative, monochrome, experimental

 Landscape, animals, nature

Bleach will damage the bristles of natural paintbrushes over time, and may corrode the metal parts of pens. If using it seems too complicated, use white pencil or crayons instead.

See also pages 91, 145, and 208.

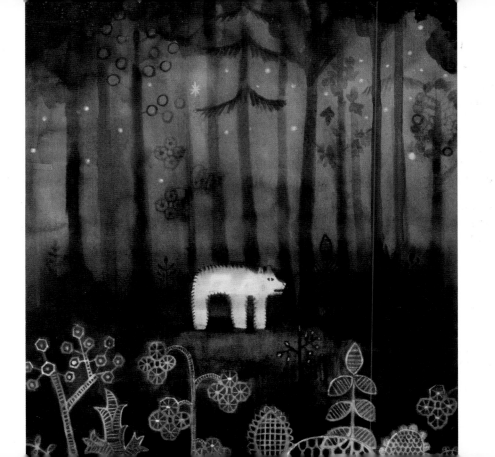

Photographic Detail

Sarah Esteje

A detailed drawing like this can only be executed with photographic reference material. Much of the skill lies in finding the right image to work from and then selecting what element to focus on. Esteje's illustration is a study of texture. The original photograph must have been high resolution, as so much detailed information has been rendered here with just a blue ball-point pen. Interestingly, it doesn't seem odd that the stag is blue. We see the drawing as we would a monochromatic photograph—as a series of tones. Esteje has built up the texture of the fur through a series of overdrawings. Ball-point pens contain a viscous ink; when it is allowed to build up, a dense, almost shiny, oily surface is the result. This makes it ideal for describing animal fur.

Esteje's drawing is elegantly composed, a factor that is in keeping with the regal bearing of the stag. His gaze is directed out of the page, engaging us. Esteje has stripped her image back to the essentials—excluding any extraneous background material—to make us focus on the stag.

 Texture, composition

 Ball-point pen

 Observational, reference

 Animals

Peter Carrington uses graphite pencil to achieve similar detail in his illustration on page 131.

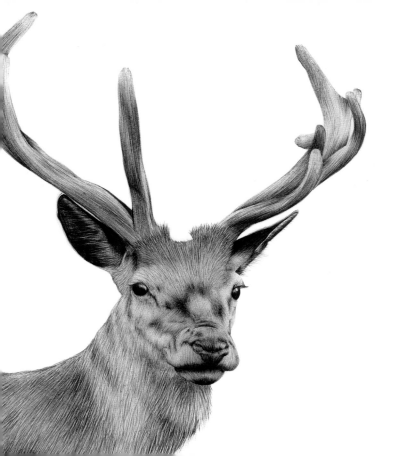

Precision and Detail

<div align="right">Peter Carrington</div>

Carrington used the most basic drawing tools for this meticulously constructed and executed drawing—a graphite pencil on a sheet of letter paper—giving it a print-like quality. Look at the attention to detail in the pencil work. He has used a number of fundamental styles to great effect. By placing the seemingly unrelated objects in a column-like composition, he gives them an emblematic quality. It isolates them on the clean white space, but we find ourselves trying to read them as one. Carrington's use of scale is also important. These items may or may not be to scale in relation to one another, but they feel "right" in relation to the page size.

 Line, composition

 Graphite pencil

 Reference, design

 Portrait, birds, text

The consistency of line here suggests that Carrington used a propelling pencil. If he had to stop and start to sharpen a pencil, it would break the rhythm needed for such precise attention to detail.

≈5000

I.I.II

Contrasting Styles

Paula Mills

Working on graph paper often lends ambience to a drawing. The lines tend to guide the hand—even if only subconsciously—to create something geometric. Here the opposite is true: all of the objects have a natural, freehand flow, in contrast to the lines of the paper. There is something experimental about this drawing. It gives the impression that a series of doodle-like marks were so successful, they have been allowed to stand as a finished work. But this does not mean the finished drawing isn't exactly as Paula Mills intended. She has set the dominant multicolored wheel deliberately off-center, and filled it with solid color to contrast with the fine black patterning she has used to fill the other elements.

 Line, color, layers

 Fineliner, graph paper

 Doodle, design

 Birds, pattern

You can achieve a similar effect with gouache or poster paint, as they are designed for use with paper, dry flat and matte, and can be drawn on.

Other examples of contrasting graph paper with curved patterns can be seen on pages 81 and 93.

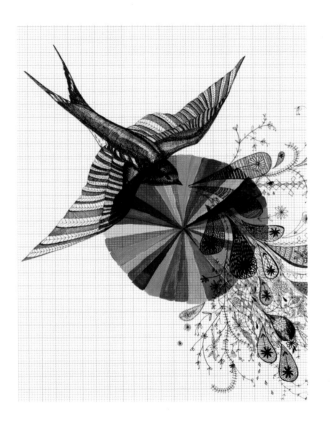

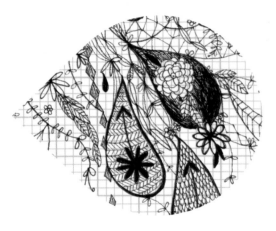

Reimagined Design

Bovey Lee

This drawing is a good example of how you can take an influence and represent it in a fresh, innovative way. Lee's paper cut was inspired by the traditional blue-and-white, Chinese-style Willow Pattern design common on ceramic plates, but has been stripped of its customary blue tone. Lee has cleverly left us with clues as to the source of the decoration: she has cut the image into a vase made of paper, suggesting a ceramic form, and included architectural details that locate the scene in Southeast Asia. However, the cutwork drawing reveals a contemporary scene with unexpected characters for such a design: a golfer takes aim; a sunbather picks up a towel; a woman dances. The beauty of this piece is in the detail—the potential story it reveals—and in the technical skill required to cut such a precise, clean-edged, stencil-like design, the components of which seem, at first glance, to fit together so well.

 Line

 Paper, X-ACTO knife

 Three-dimensional, imaginative

 Landscape, people

You can research the many sources of Willow Pattern ceramics online.

You can see an example of paper cutting used to create a photographic effect on page 115.

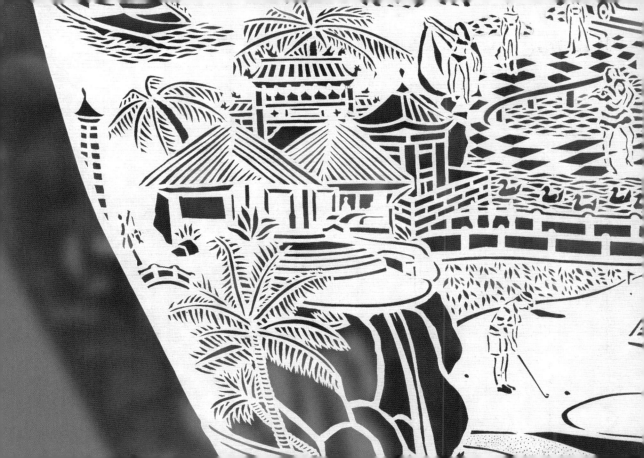

Repeated Image

Craig McCann

Some subject matter lends itself very well to the notion of repeat. In this image McCann has transformed one bird into a flock and placed that flock on a diamond-like grid to give a strong graphic impact. The bird is largely a work of imagination—McCann has played with shapes and textures for visual impact—but based in reality.

McCann experimented with scratchy pencils, broken and deliberately damaged pens, and heavy sticks of graphite to create texture, then scanned and reduced the results to create the bird. Drawing at a larger scale than you intend for the finished piece helps you produce different weights and qualities of line. He added finer line details with a Rotring pen and muted colors as finishing touches.

 Composition

 Ball-point pen, black ink, digital, graphite pencil

 Imaginative, digital, design

 Birds, repeat

You can scan, digitize, or photocopy images to reduce them. To repeat this motif, McCann used the Filter > Other > Offset function in Photoshop.

See pages 19 and 163 for other drawings built up with repeated images.

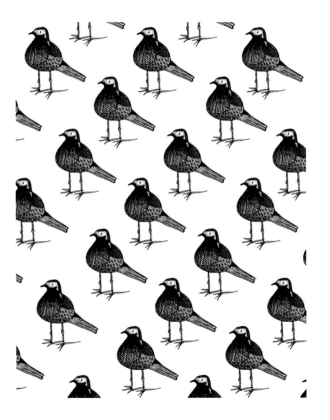
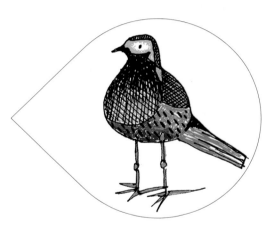

Depicting Motion

Valero Doval

Doval has collaged photographs onto cream paper for his zeppelin drawings. By using this yellowed paper, he has made the drawings appear older than they are, which picks up on the obsolescence of the subject matter. His placement of the zeppelins is significant. The mostly unfilled paper around the airships, the negative space, provides an airiness that helps to describe the characteristic momentum of these machines, giving them room to float. Doval has added Spirograph patterns and incidental lines to reinforce this sense of movement and flight path.

 Composition

 Collage, Spirograph

 Collage, reference

 Urbanscape, objects

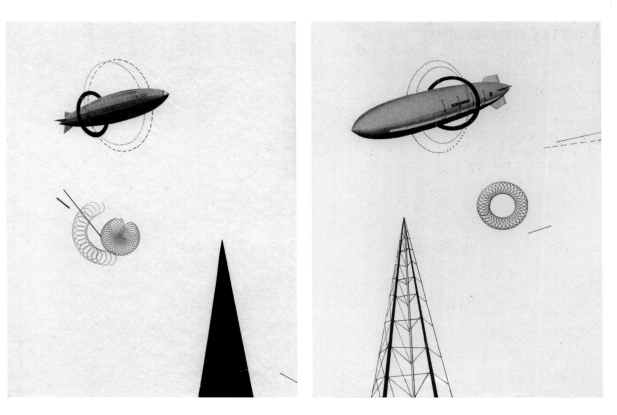

139

Intricate Detail

Rosalind Monks

Monks used a fine line to render the framework for the exoskeleton of this insect. It has a symmetrical feel to it, but the two sides of intricate latticework are different. Despite the complex pattern—which suggests a piece of lace or filigree jewelry—the drawing has a hand-rendered feel; it has not been drawn with or enhanced by a computer. The original was made at a much larger scale than shown here. If you want your drawings to have very fine detail, this is a good technique. Draw it at a larger size than you want for the finished image, then photocopy or scan your original to reduce it. Many illustrations are shown in a reduced format to enhance fine detail.

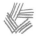 **Line, scale**

 Fineliner

 Observational, imaginative, design

 Animals

You can lose a sense of the overall scheme when you work with this kind of detail, so use pencil guidelines to give you a sense of space and form first.

Paula Mills used Photoshop to achieve a uniform tone in her fine linework on page 61.

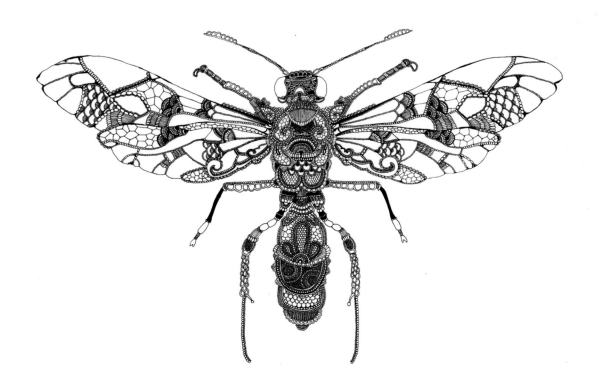

Repurposed Book

This is an interesting way to approach illustration: drawing directly onto the pages of an antique book, or imposing them digitally. The way the book is flattened suggests that it has been photocopied or scanned. Chen has gone to some lengths to disguise the "real" book, adding pencil marks to transform it into a drawing. He has made no attempt to draw Chopin in a style that is in keeping with the age of the book. The felt-tip lines of his coat and cravat are clear and the harlequin pattern behind him is clearly from another era. The portrait is taken from a pen-and-wash likeness of the composer that Chen has flipped digitally. Perhaps the composition worked better this way. Such are the choices you can make when you follow this approach.

Color, shading

Felt-tip pen, watercolor, digital, graphite pencil

Reference, narrative

Portrait, text

Chen's use of signs and symbols adds a narrative to this piece. The bleeding heart, the waiting handshake, a mountain, and a grave suggest a difficult life for this Romantic composer.

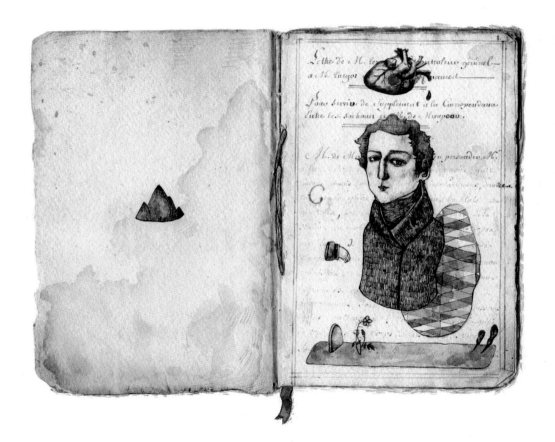

Shining Light

Dain Fagerholm

Fagerholm has enhanced the fantastical, otherworldly feel of this drawing by combining marker pens, felt-tip pens, and fluorescent markers to produce an almost luminous, textured surface. His success is due partly to the way he has combined the materials. He has laid down every line, apart from the fluorescent ovals that make up the creatures' eyes, with a scribbled or back-and-forth motion to build up a rich surface. The ground and night sky are composed of a three-color, swirling, layered scribble; the creatures' fur, of four or more colors, laid down in more ordered rows.

The really clever part is Fagerholm's use of a fluorescent pink marker pen to suggest the emission of a strange light from the geometric gem. Look at the pink area on the ground between the creatures and the pink shining on to them. A sense of light shining within a blue-black drawing is really clever. No wonder the creatures are hypnotized.

Color, texture

Marker pen, fluorescent pen, felt-tip pen

Imaginative

Animals

See also pages 91, 127, and 208 for other examples of drawings with a sense of light shining from within.

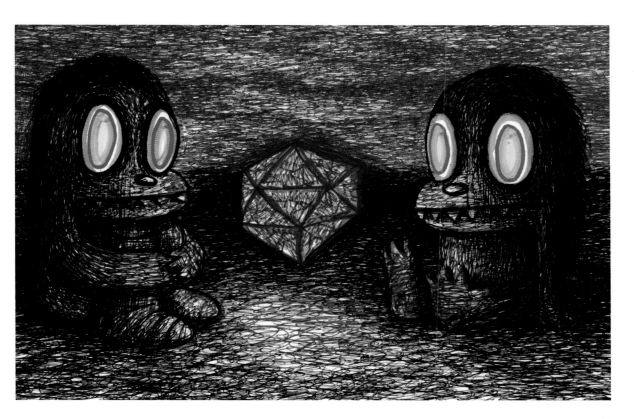

Tonal Shifts

Lyvia Aylward-Davies

This unusual portrait is made up entirely of triangles drawn in felt-tip pen. Aylward-Davies began by mapping the areas to be colored in order to define the boundaries of each one—without these guides it would be very difficult to execute such an idea. Despite this planning, there is also much spontaneity. She uses tonal shifts to help define the facial features: a pale orange for the central part of the face and the closed eyelids, and pink and red for the lips and cheeks. She contrasts the uniformity of color in these zones with a more complex approach to the golden hues. These create a mosaic-like effect, which, together with the emphasis on gold, suggests Byzantine art.

 Line, color

 Felt-tip pen

 Imaginative, doodle

 Portrait

You can see other examples of pattern-filled outlines on pages 35, 109, 149, 153, 159, and 169.

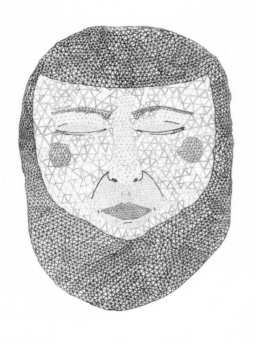

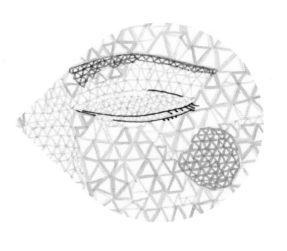

Signature Tag

These are no ordinary drawings. Boey has turned disposable Styrofoam cups into collectible art through applying his distinctive style. The indelible marker pen he uses has a big part to play in this: its dense, black, permanent, clean-edged, consistent line has a quality we see in printed matter or more graphic visuals. There are common motifs hidden in his patterns—small bunnies and figures. Look at the neck of the phoenix, the waves of the sea, and the clouds. This device, or tag, has become one of the signature marks of the artist. Unlike the visible tags/signatures we might find in street art, these are at such a small scale, we can no longer see them. Rest assured they are there. Leaving a tag has become one of Boey's signature marks, and made these cups much sought after. But Boey's art involves more than this tag. There are many stylistic influences at play. His clean, black lines are reminiscent of Japanese prints, of tattoos, and of graffiti; his dots have a Pop Art, newsprint, or comic-book feel. His sense of craft is at odds with the throwaway drawing surface.

 Line

 Marker pen, found surface

 Imaginative, design

 Seascape, landscape, animals, birds

You can see other examples of pattern-filled outlines on pages 35, 109, 147, 153, 159, and 169.

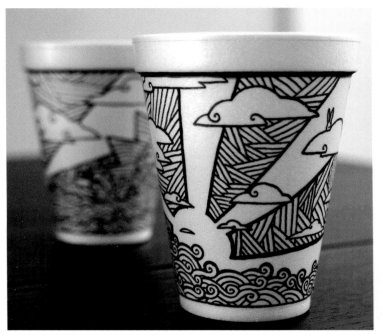
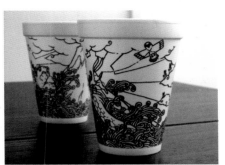
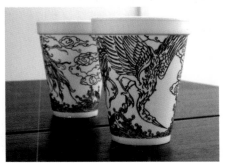

Spatial Depth

Mark Lazenby

This drawing cleverly suggests spatial depth and perspective. At the same time the origin of the paper remains obvious, with its book layers visible, and the yellowing edges adding to the feel of the piece.

Lazenby chose specific pieces from his collection of found paper to fit the theme of summer gardens, and built up this collage in layers, drawing with an X-ACTO knife. He has cut out most of the larger blooms from the foreground (the top layer) to produce negative shapes that allow the text on the page beneath to show through: a list of garden flora and fauna. Lazenby has formed the background with a small black-and-white cutout of a building. Its scale, and his placement of it in white space, make it look distant.

 Line, composition

 Found paper, X-ACTO knife

 Collage, conceptual

 Landscape

We tend to concentrate more on the medium we are going to draw with than the surface we plan to draw on—try to reverse that habit from time to time.

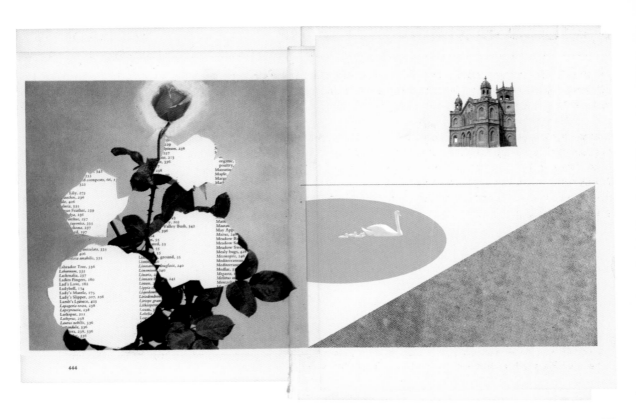

Overlapping Shapes

Jamie Palmer

This stylized drawing has a very organic feel that suits its suggested subject matter—flowers—and the way it was constructed. Palmer overlapped a series of circular motifs, but not so many that their varying textures overwhelm the design. Palmer has filled most of the motifs with gently curving, freehand lines, but he has completed some using a ruler to create radiating lines or zigzags. The subject matter combined with the mixture of precision and pattern in this drawing give it a very Japanese feel.

 Line, scale, layers

 Fineliner, marker pen, ruler, sketchbook

 Doodle, imaginative

 Nature, pattern, repeat

You can use a compass to draw a circle, but remember it will leave a hole in the paper. To prevent this, draw around a circular object of the required size.

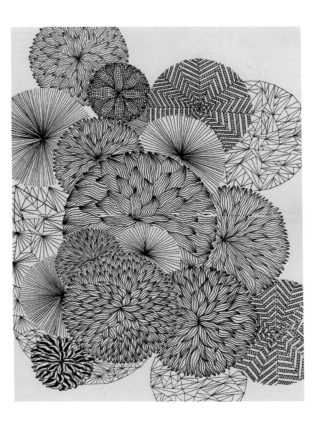

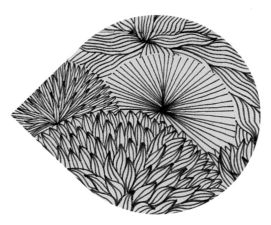

Single Image/Many Stories

Jeffrey Decoster

Slightly distorted figures overlap in this adrenaline-laden flurry of sporting action. Decoster cleverly suggests risk by including a rocky outcrop on the right, colored red to signify danger. He uses a red "tightrope" to slice the drawing into two sections. Most of the action sits above this curve. A random glove falls beneath it toward what could be gray sea or rocky terrain. This red line is a useful device: it signifies water, snow, ledge, and ground, depending on which figure you apply it to. Decoster's colored outlines enable us to separate the action of the various figures, which he has traced from photographs.

 Line, layers

 Fineliner, gel pen, colored ink, digital

 Conceptual, reference

 People

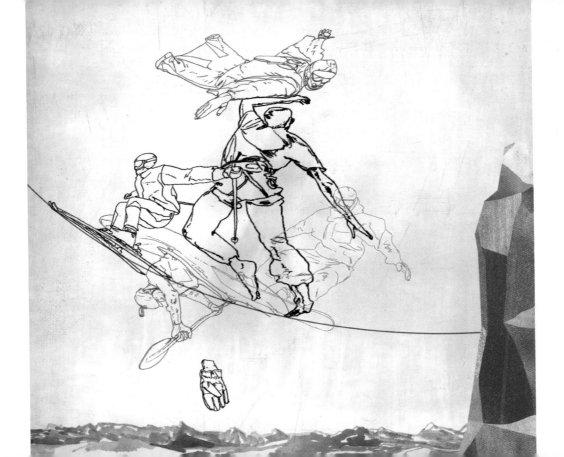

Smartphone Apps

Manuel San Payo

The subject matter, medium, title (*Thursday Tree*), and artist of these two drawings are all the same, but the outcome is not. This option to change your mode of drawing quickly, and with a minimum of fuss, is the beauty of digital drawing.

Both trees are spontaneous drawings made with finger swipes on smartphone/tablet screens. San Payo selected similar tools from the apps he used, but tweaked the settings to produce varying line qualities. One (green) favors a chisel-tip, marker-pen style; the other (pink), a smoother, translucent layering of line. There is also a contrast in the surface effect of each: the green drawing appears textured, the pink one to have no texture at all. Texture can only be a suggestion, of course, as these drawings were made on a flat glass screen. The great thing about the brushes in these apps is that they allow you to lift and apply textures and layers from elsewhere. This may be from photographs or saved brush textures. To the green drawing, for instance, San Payo has added subtle fingerprint dabs here and there.

 Line, texture

 Smartphone, tablet

 Digital, observational

 Landscape

You can take textured effects further by printing digital drawings on to different papers. Remember that when drawing digitally, you are drawing with light. When you print off that same drawing (creating the drawing with pigment, rather than light), the colors may appear less luminous.

For more about drawing on a smartphone or tablet, see page 198.

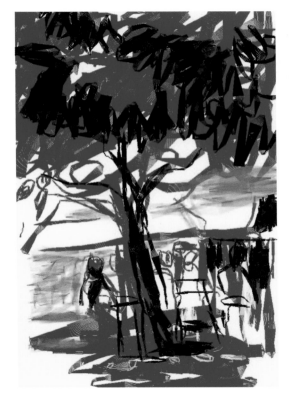

Representing Sound

Frida Stenmark

How to draw sound is an interesting proposition. Sound is usually depicted in a more abstract way than here: through the movement of a conductor's baton, the action of a dancer, or the pulsating needle trace of a monitor. Sound can be thought of, or conceptualized as, something comprised of color as well as shape. Stenmark has used pink to depict the sound produced by a gramophone. There is something quirky about this antique, windup machine, with its characteristic horn-shaped loudspeaker, especially in this age of digitized audio output. The pink implies a soft, warm, comforting sound. The dashes of pencil might describe the crackles caused by scratches on the record. The balloon-like form could show the limit of the sound. The wood grain of the gramophone and the overlap of the pink sound cloud against the horn are subtly handled. A touch of fine black pen line completes the piece, but this is not used around the pink cloud.

 Line, color

 Colored pencil, felt-tip pen

 Conceptual

 Still life

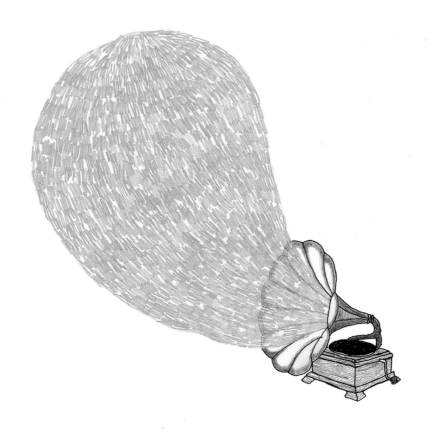

159

Silhouettes

Pablo S. Herrero

Silhouettes are good forms to experiment with. Their success depends on the medium and the composition. Herrero used an incredibly dense black for these silhouettes. You could try China or India ink to create a similar deep color. This type of ink is indelible and lightfast. It can be diluted with water and is excellent for use with brushes, nib pens, and other dipping implements. A simple twig, stick, or feather dipped in this ink will make lovely marks and drips. However, it is not suitable for use in fountain pens. The type of paper you choose is also important. It needs to be durable and absorbent to withstand repeated wetting. If you look at the edges of these illustrations, you can see the area that was washed with water. This created a surface tension into which Herrero brushed and dripped the blue and thinner black inks. Once the paper was dry, he added the tree silhouettes using a brush and a dip pen. Similar "twig" effects can be achieved by blowing at the ink through a straw.

 Line, composition, layers

 Colored ink

 Observational, experimental

 Nature

You could try using cold-pressed, thick watercolor, or rag papers for this technique.

Background washes also feature in the images on pages 55 and 97.
See page 212 for how to stretch wet paper.

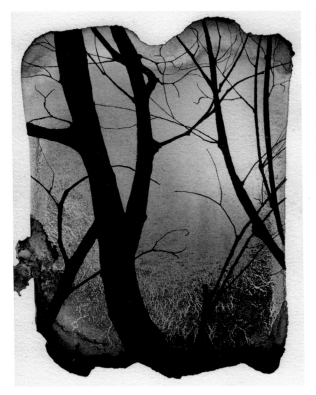

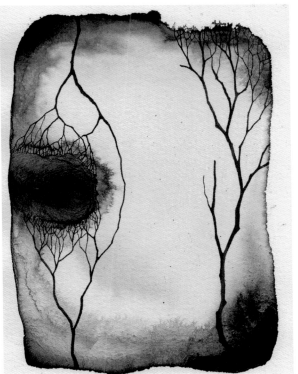

Color Wash

<div align="right">Catherina Turk</div>

In this drawing, Turk takes a very simple form and repeats it, over and over, until the page is full. Her methodical rhythm is tangible and gives the sense that the image was constructed at a gentle pace. Turk's color choice enhances this: she uses a subtle wash of red and green, which changes from tear to tear, rather than strong, saturated versions of these primary colors.

Use water-soluble media to achieve nuance in your work. When you draw with water-soluble pencils, brush pens, or ink, the solidity of the color is likely to be inconsistent. Sometimes you will want to make a color uniformly flat, at other times you won't. The trick is to practice both approaches, to accept all characteristics of your chosen media, and to know when best to use them, as here.

 Tone, color

 Colored ink, watercolor pencil crayons

 Design

 Pattern, repeat

Pattern-based works are open to multiple interpretations. Turk describes this as a teardrop drawing, but it can also be seen as an aerial view of rows of trees.

You can see other illustrations that use a repeated image on pages 19 and 137.

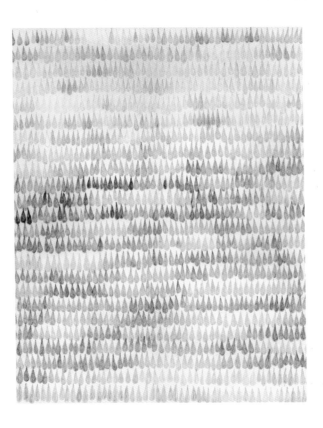

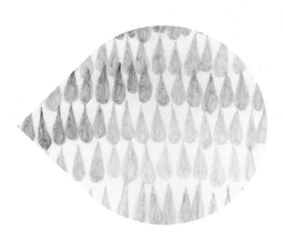

Black Background

Sophie Lécuyer

Drawings are usually a dark line on a pale ground. This is the opposite: the background is a solid black and the image composed of white lines. Take a new approach to your drawing from time to time; play with the medium and technique you use. This will help you to think differently, to try new things.

A solid black, as Lécuyer has used, could be drawn on to or into. If you decide to draw on to a dark ground, you will need something opaque enough to show up. A good-quality white ink would work, as would a white pencil or gel pen. If you choose to draw into the surface, consider a sgraffito technique. For this, the surface must be covered with something you can "scratch" away: a soft oil pastel is ideal. You can use the tip of a compass, an inkless ball-point pen, or a nail.

 Line, layers

 Colored paper, colored ink, oil pastel

 Imaginative, narrative

 Portrait, nature

Think about what you will draw as well as what you will draw with. This image suits the reversing of light and dark: the couple could be a modern take on Adam and Eve, or a night scene with nocturnal wildlife.

The images on pages 23, 41, and 203 also use white on a colored background.

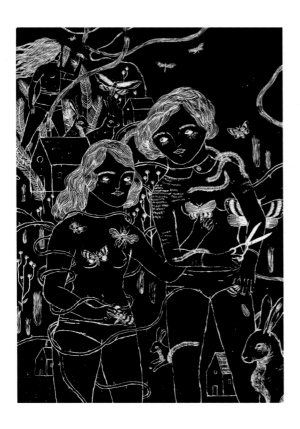

Texture and Tone

Violeta Lopiz

Lopiz makes use of the full tonal range in this unusual double portrait, which is, essentially, a gray-toned image. She has made use of the textured paper to add visual interest, allowing the crisscross texture of the surface to show through her subtle line shading, particularly in the skin tones on the man's face, and, in a more subtle way, each side of the woman's neck.

Techniques and tone are only a small part of the success of the image. These are clever character studies, expressing clear emotions. The woman's round mouth clearly makes an "oh" sound, and Lopiz mimics that round shape with the red circles on her cheeks. She echoes the man's quizzical eyebrows and his dapper mustache in the stripes of his clothing. This drawing is a series of contrasts: circles and stripes, woman and man, black and white, lustrous hair and no hair—and a shot of red in the gray.

 Tone, texture

 Paper, collage, print transfer

 Monochrome, narrative

 Portrait

Part of what makes this image fascinating is that it's not possible to tell how it was all done. There may be a print transfer. The buttons and striped top have a newsprint-like surface. The clean edges between some areas of tone, especially the woman's dark hair, suggest a collage technique.

See pages 103, 133, and 189 for other drawings that contrast a bright color with black and white.

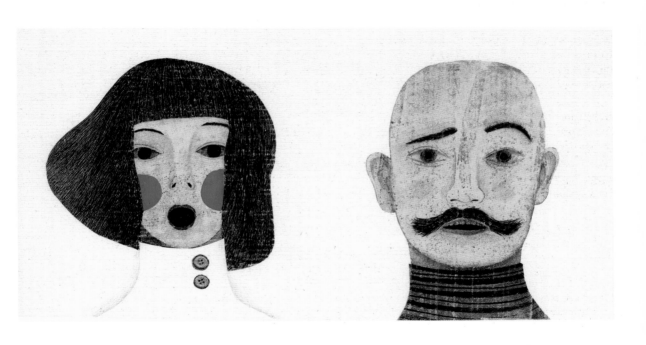

Trompe l'Oeil

Caitlin Foster

Something interesting happens when you view this drawing: the lines create a strobing, three-dimensional effect. By confining the pattern within a geometric shape, Foster focuses our attention on it. With our gaze held, the blue lines start to ripple and flow across the surface, creating their own rhythm. Because the blue ink lines are not of a uniform thickness and are made of pattern too, they give the impression that they are zigzagging back and forth. They play tricks on our eyes. This is a pattern made from pattern.

 Line, texture

 Colored ink

 Abstract

 Pattern, repeat

A number of illustrations in this book use repeated patterns with graphic shapes. For an interesting selection, see pages 35, 93, 109, 149, and 153.

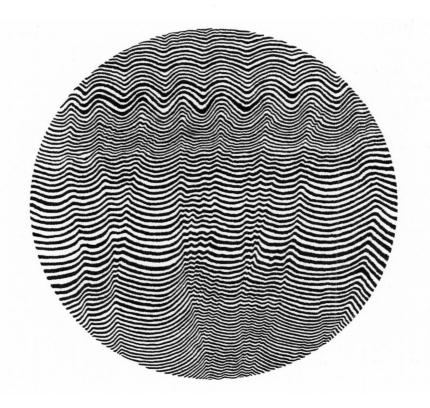

Understatement

<div align="right">**Emily Watkins**</div>

The impact here comes from Watkins' introduction of bright red highlights to an image that is otherwise free from variation. Watkins cut the simple shape of the birds' bodies from found papers: brown envelopes—some with their postage stamps intact—and lined paper. The outlines vary in size alone; the color scheme is a harmonious, even monochromatic, one; and she has kept the surface qualities understated, adding only pencil-line feathers to the blue margins on the lined paper and the subtle texture of the brown paper. In contrast with all of this is the flourish of the red beaks and legs adorned with boots.

 Color

 Found paper, marker pen

 Collage

 Birds

It is intriguing that some of the text on the papers is back to front. Perhaps the birds all faced one way to begin with, but the drawing looked better with birds feeding in random directions.

The image on page 69 adds drawn detail to found papers.
See page 210 for more on harmonious colors.

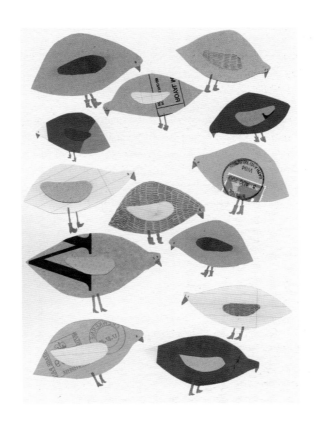

Surface Pattern

Sandra Dieckmann
and Jamie Mills

An African elephant dominates this composition. It is slightly whimsical, but wild too. Squeezed into the frame, this large animal makes an interesting illustration. The landscape format provides ample space for those large ears. While Dieckmann has used a photograph for reference, she has interpreted rather than copied it. She has enhanced the whole elephant—skin, ears, and tusks—with patterns. It still retains the gray skin we would expect, but that flat tone is covered in linear, tribal markings. Mills' tall, outlandish plants provide color: the primary colors of the flower heads are a good counterpoint to the dominant gray tones elsewhere. They frame the elephant and provide a shallow depth where their dark gray stems overlap the elephant's form. Pattern and portrait make good partners here, with one enhancing the other. Dieckmann applied simple pencil lines as a doodle-like fancy (triangles, checks, chevrons, dots, circles, diagonals, loops, striped edgings, and some symmetry too) and Mills dabbed gouache as painted petals to enrich the surface.

 Format, color, line

 Graphite pencil, colored pencil, gouache

 Reference, doodle

 Animals

You can try a similar approach by drawing patterns on to magazine images or photographs. Ball-point pens and indelible marker pens work well on shiny, printed papers. If you want to use pencil, copy the images onto matte paper first.

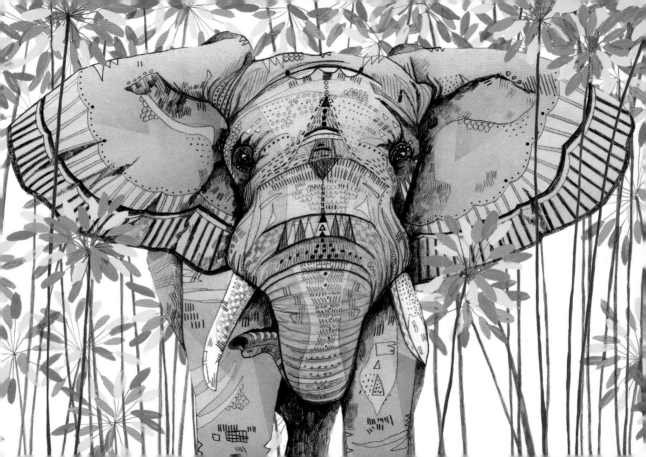

Tints

Jennifer Davis

This mixed-media drawing has a lightness of touch that suits its title, *Remember*. Davis has painted with tints rather than shades of color, making it light and pale. To me, it describes the ephemeral and random nature of memories. We see seemingly disjointed objects floating in an insubstantial space. The only sense of grounding Davis has included is a little tone under the wheels of the bike and a suggestion that the bunting is anchored just outside the frame of the image. By using tints for the whole work and setting her drawings on a flat, uncluttered, cream background, Davis has given the image a misted and dream-like feel. She has also achieved a pleasing balance by echoing the shape of the bicycle wheels in the circles of the flower and the memory bubble of the dog, by edging everything with a fine gray line (a tint of black), and by including stripes here and there to act as a counterpoint to the overall flatness.

 Color, line

 Graphite pencil, paint

 Imaginative, narrative

 Portrait, animals, still life, objects

Using tints and shades can be useful. Experiment with your chosen tint/shade scale first. You'll waste less ink or paint if you add a touch of white/black to start with. You can add, but you can't take away.

You can see more illustrative portraits on pages 59, 167, and 183.
For more on tints and shades, see page 209.

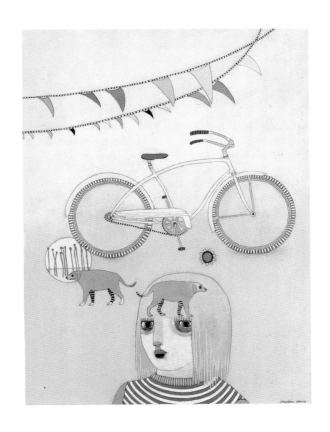

Unifying Collections

Bryce Wymer

Carry your sketchbook with you and you will always have a place to jot down ideas and try out new things. Don't be afraid to experiment. Look at these pages from Bryce Wymer's sketchbook. The drawings may be separate objects that don't naturally go together, but they flow across the pages. The scale of the different pieces doesn't make sense—human heads are drawn larger than a ladder or chimney—but the disparate objects read "as one" because of Wymer's consistent use of a black ball-point pen, a pink marker pen, and a labeling code. Wymer has given most of the objects a slight shadow to the right. This anchors them and gives them a sense of gravity. Only one significant object—the airplane—has no shadow, and therefore appears to fly. There is a confidence about this collection of drawings, and a sense of fun. Experiments are tried and potential solutions found—exactly what a sketchbook is for.

 Line, composition

 Ball-point pen, marker pen, sketchbook

 Imaginative

 People, objects

See pages 31, 67, 73, and 123 for other sketchbook illustrations.

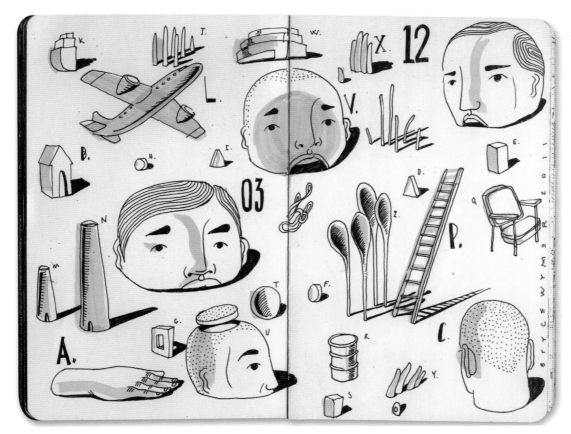

Unifying Themes

Fred One Litch

There are great sources of raw materials for collage all around us: photographs, magazines, and images from websites such as Flickr. The trick is to save, collate, and try them out. Found papers make for interesting drawings, whether you draw on them or with them. Both of these techniques are used here. A collage drawing is an image made up of seemingly disparate parts, the skill being to find a theme to bring those parts together successfully. There are several uniting factors here. The colors sit well together. Translucent papers are overlapped to create new halftones as they mix. The found papers have fragments of drawing on them. More black lines are drawn and glued to the top surface. Black is an important part of this collage drawing, pulling the composition together.

 Composition, layers, color

 Found paper, fineliner

 Collage

 Nature, pattern, birds

You can use black line as a unifying theme to combine a traced drawing or other work with fragments of found handwriting.

You can see another example of collage and drawing combined on page 204.

You can see another example of collage and drawing combined on page 204.

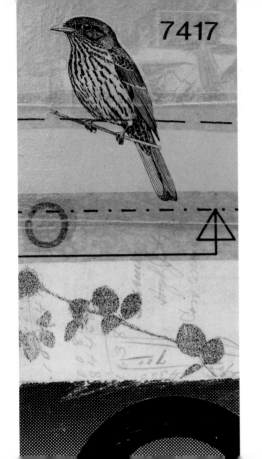

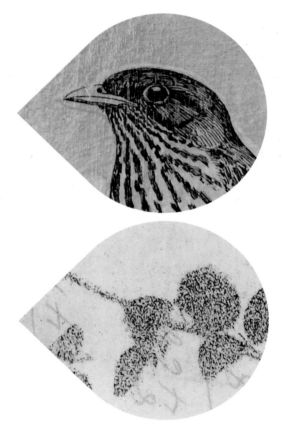

Zonal Texture

Sandra Dieckmann and Jamie Mills

Anthropomorphism helps us to connect with this illustration. It is difficult not to attribute some human characteristics to this polar bear. Dieckmann specializes in drawing animals, and this is part of Dieckmann and Mills' series about endangered species. The polar bear is set against white, ideal for its snowy habitat. Mills has alleviated this with an inky splash of color. Taken positively, this suggests water droplets—that the bear is shaking itself dry; looked at pessimistically, this is its blood or life ebbing away. The way Dieckmann built up the texture and layers of fur is worth scrutinizing. She drew the hairs not one by one, but almost in zones. The blackest shading, and the most solid use of pencil, describes the eye slit, the soft velvety nose, and the inner ear. She applied the graphite pencil work with some tone and shade, but mostly as linear patterns: dashes, softer lines, and triangular points too. This is an unusual way to draw fur, and one that works really well. It is one of the artists' signature styles.

 Line, texture

 Graphite pencil, colored pencil, colored ink

 Observational, imaginative

 Animals

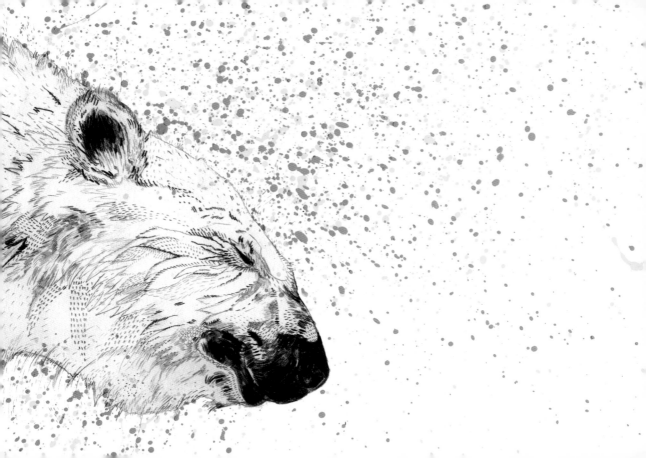

Visual Metaphor

Kate Pugsley

I see this deceptively simple combination of collage and pencil line as a visual metaphor. The "flag of teeth" seems an odd thing to depict in such a whimsical manner, but the title of the drawing—*Nerves*—is an important part of how we read it. We have to ask questions and find meanings. The proportion of the figure suggests she is a child, but somehow that feels like a stylistic convention. Maybe this is about someone on the cusp of adulthood. Either way, Pugsley has created a narrative, concept, or visual metaphor with this device. She has used papers of varying thickness in her collage, which shows up in the final scan of the drawing. This helps the whole thing to appear slightly three-dimensional—a good finishing touch.

 Construction, color

 X-ACTO knife, graphite pencil, colored pencil, colored paper

 Imaginative, conceptual, collage

 Portrait

For other examples of illustrative portraits, see pages 59, 167, and 175.

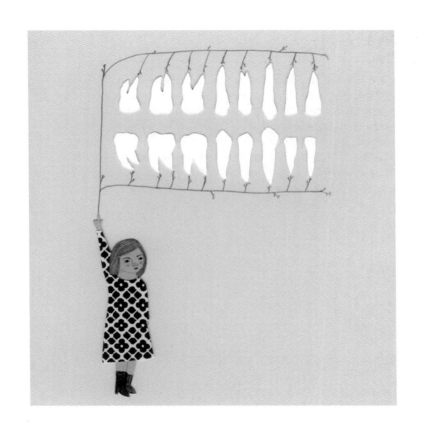

Unexpected Color

Nikki Painter

Taking a different approach to drawing a landscape has many rewards. Painter's landscape has the traditional elements of foreground, mid-ground, and background, but it appears that these have been sourced from more than one landscape to make a composite image. By layering these different elements, Painter lends a three-dimensional aspect to the two-dimensional plane and gives the drawing perspective. She has not used traditional colors. Her fluorescent pink, orange, yellow, and green are super-enhanced and enliven the layers of pattern. Your eye is caught by the concentration of color in the foreground and led through the more "diluted" middle ground to the patterning in the black-and-white sky, increasing the sense of depth in this scene. The non-colored, non-patterned parts of this drawing are an important counterbalance to the detail elsewhere, and Painter's clever use of white space produces the shapes of the trees.

 Line, color, layers

 Black ink, colored pencil, graphite pencil

 Observational, design

 Landscape, nature

The image on page 89 shows a very different approach to a landscape, though it also uses unnatural colors.

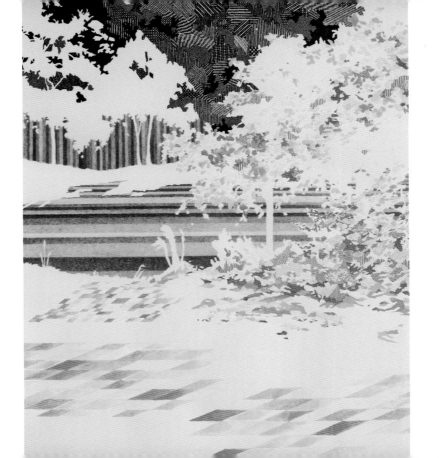

Visual Clues

Wendy Marchbanks

The idea of a landscape is palpable in this abstract arrangement. Although Marchbanks gives us no sense of perspective, she gives us enough visual clues for us to treat it as such. It is unusual to see a composition in which, although there is plenty of room, objects are set on the edge of the paper. Yet here they even go off the edge. This is an interesting ploy: it makes us look again at the objects and try to make sense of them. Marchbanks' placements are reminiscent of wallpaper; repeats of the drawing can be aligned by the two diamond halves, though this leaves the tree on the left edge incomplete.

 Composition

 Black ink, colored ink, colored paper, digital

 Abstract, design

 Landscape, pattern, repeat

The detail on the series of geometric forms, drawn in black line and in-filled with black, suggests they were drawn at a much larger scale and reduced to fit. The flatness of the pink path and the abstract pale-blue pond suggests that they were produced digitally.

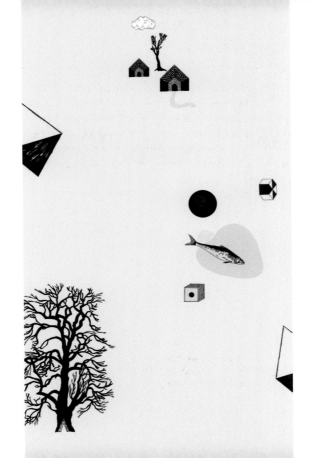

187

Off-Center Composition

Donny Nguyen

Although it is from a sketchbook, there is nothing truly "sketchy" about this drawing. Only the intense red crosshatching just behind the sitter, and the red blocks of tone below the bow, suggest that this is the start of something yet to be finalized. The placement of the drawing, neither centered nor confined to a single page, is a useful trick to know. Composition can really enhance your drawings. Annie, the subject, seems to scrutinize us as much as we scrutinize her. Nguyen distracts our gaze from her face with the dramatic red-checked bow she wears and makes it difficult for us to focus our attention: our gaze is torn among the finely crosshatched tonal rendering of her face, her knowing eyes, and the vibrant red linework of her clothing.

 Line, tone, composition

 Ball-point pen, fineliner, sketchbook

 Observational, imaginative

 Portrait

See pages 103, 133, and 167 for other examples of using bright color with black and white.

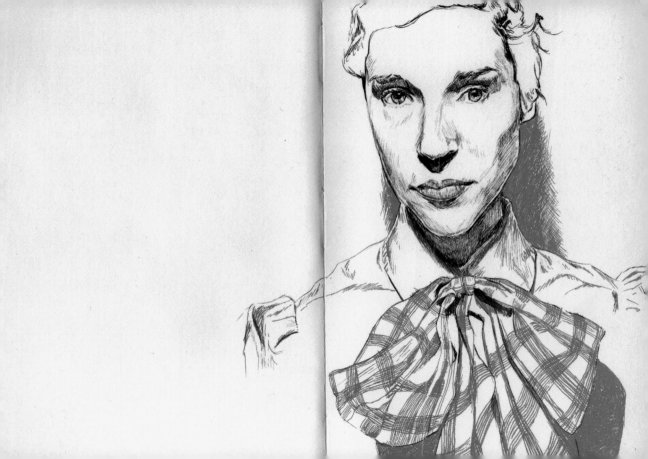

Utilizing Marks

Diego Naguel

Having a ready supply of found papers is always a good thing. Look at all the marks on yours: they can be put to use. For this stag, Naguel has used the yellowed, dog-eared, spotted base paper to pick out the marks and colors within the main body of the drawing. He has used the not-quite-erased pencil marks elsewhere, the glue smudge, and the printed text that shows through from the reverse, to add visual interest.

Making drawings like this reevaluates materials that others might discard. It imbues the work with a tinge of nostalgic know-how: a make-do-and-mend philosophy. It also makes a drawing feel craft-like.

 Layers, line

 Found paper, fineliner, graphite pencil

 Doodle, collage, reference

 Animals

If you have a collection of found papers, make selecting from them easier by ordering them by color, texture, and perhaps those with and without text.

You can see other drawings that use layers to suggest depth on pages 97, 155, 197, and 204.

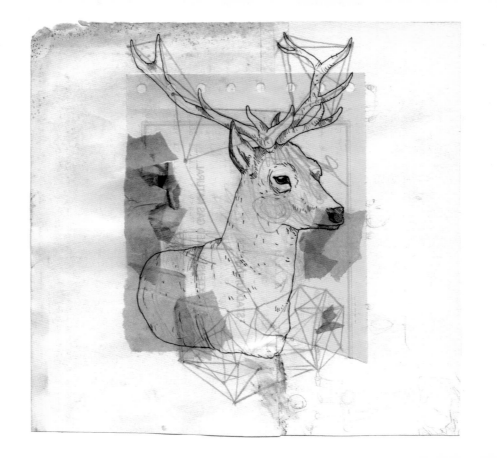

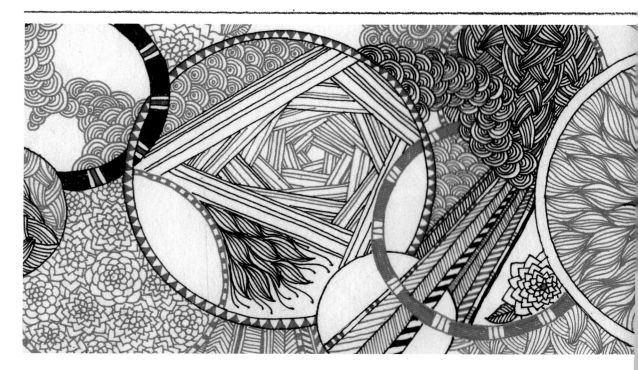

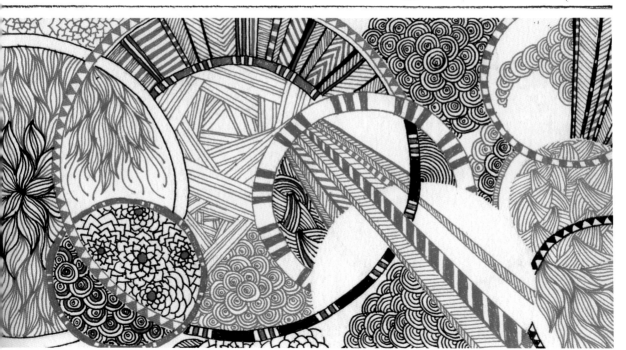

Elements

Line

Line is an elemental part of drawing. Any medium used to make a mark on a surface will inevitably leave a line or a dot. We use the drawn line to show what is in front of us, or to depict an idea that is in our mind. Think of its day-to-day use: quickly sketching a map, writing a shopping list, putting on eyeliner, or mindlessly doodling. Line as a drawing, as opposed to any of the above uses, formalizes that mark. We are giving it a specific job and allowing it to stand alone. The surface you choose to make a mark on, and the medium you choose to make that mark with, will start to define that drawing. But all we really need to know is which materials make what sorts of lines. And we need to experiment as much as possible.

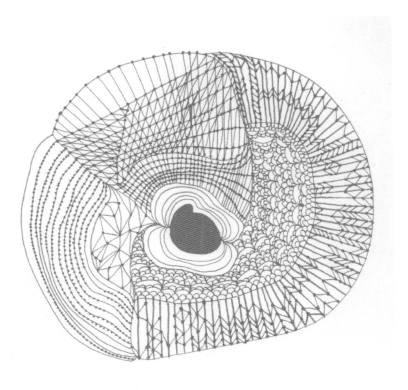

Far left: Drawing by
Jane Pawalek; Illustrator

Left: Drawing by Ana Montiel; ink

Above: Drawing by Frida Stenmark;
fineliner, felt-tip pen, ball-point pen,
and propelling pencil

Physical Media

Broadly speaking, it's easiest to divide line-making media into two categories: dry and wet. In addition to these are media that can be used to *make* rather than *mark* lines. The quality of your drawing materials is important. If your art supplier allows, try to experiment with new media before you buy. If not, ask for advice. A good supplier will be happy to share his or her knowledge.

Dry Media
- graphite/lead pencil
- colored pencil
- charcoal (willow and compressed)
- pastel
- pastel pencil
- oil pastel
- pen: fineliner, gel, ball-point, fiber-tip/felt-tip, marker, dip
- tape
- digital: apps and programs

Right: Drawing by Sara Landeta; dry media

Far right: Drawing by Jeffrey Decoster; wet media

Wet Media

- water-soluble colored pencil
- India and China ink (waterproof)
- colored ink (soluble)
- watercolor
- gouache
- acrylic paint
- masking fluid
- bleach

Other Media

- eraser
- fixative
- X-ACTO knife
- scissors
- compass
- ruler
- glue stick
- pencil sharpener
- sandpaper
- drawing board
- brushes
- Spirograph

Digital Media

Before the advent of apps, most digital drawing was done using basic computer programs, often packaged with text documents, and they weren't very good. At the other end of the spectrum were very complex (and expensive) packages such as Photoshop and Illustrator. The latter are still the main choice for illustrators and artists, but it is possible to get educational discounts on them, and "part" packages too. Various open-source versions are also available online. These include GIMP, Picnik, Inkscape, and Serif DrawPlus. As usual, the best idea is to shop around.

Apps for Smartphones and Tablets

The number of drawing apps available makes it really easy to draw on the move. While the names of these apps often suggest they are just for painting, they also offer plenty of possibilities if you want to draw. Take a look at Paintbook, Layers, Brushes (an app used by David Hockney), Artrage, Procreate, Paper by Fiftythree, Sketchbook Express, and Infinite Design. Your choice will probably be influenced by what you want to use it for, the price (although some of these are free), and your platform (IOS or Android). Again, do your research: try things out, read as many reviews as you can, and look at the art made by others using them.

Digital cell-phone images can be turned into pseudo drawings. Pencil Illusion, Paper Camera, Etchings, PowerSketch, and Halftone (for comic book–style images) will all give you drawings for which no drawing took place.

Digital output can be very exciting. Print your digital imagery on to paper, cut it up and make a collage with it, draw on top of it, rescan or photocopy it, even repeat all of these things ad infinitum. Combine analog and digital, old and new, actual and virtual . . .

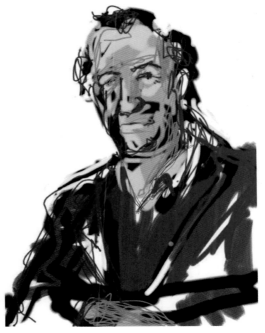

Left and above: Drawings by Manuel San Payo; created using drawing apps, applying various line-width settings, color palette choices, and layering options

Tone

Line has no three-dimensional value. We use tone in drawing to describe three-dimensional shapes on a two-dimensional surface. Tone, sometimes called value, refers to the range of light and dark areas in a drawing. By understanding tone you can create a strong sense of volume or three-dimensionality in your work. Everything we see in nature is one tone sitting next to another—there are no lines. If you understand this premise, it's easier to complete a 100-percent tonal drawing.

Tone is strongly influenced both by what you draw with and what you draw on. Below you can see the same tonal scale, ranging from dark to light: one created digitally, and the other drawn using graphite pencil on textured paper.

A very soft pencil drawing on a textured paper will have a different range of highlight (white tones) and shadow (black tones) from a drawing done with a hard pencil on a flat paper surface.

Adding Tone

Tone can be added in a number of ways: through crosshatching, stippling, smudging, dashes, and dots (dry media); or as a wash (wet media). It can also be "knocked back" or lightened by using an eraser for dry media and a wetted brush or diluted bleach for wet media.

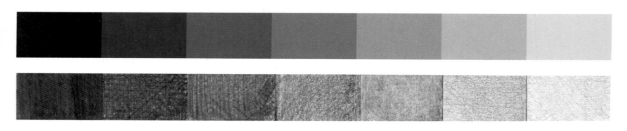

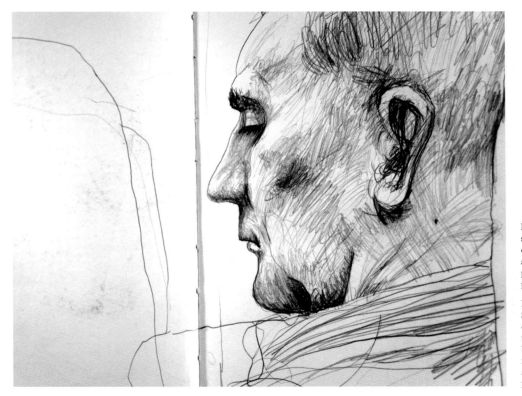

Far left: Tonal scales created digitally (top), and with graphite pencil on textured paper (bottom)

Left: Drawing by Steve Wilkin (see entry on page 122); tonal range achieved by layering pencil marks, crosshatching, and varying the pressure applied

Paper

The surface or feel of a sheet of paper—how rough or smooth it is—is called its *tooth*. The surface texture can greatly influence how a drawing looks, what it feels like when you're in the process of drawing, and how drawing materials adhere to it. Just as there are many things to draw with, there are many different things to draw on. The choice of surface often comes a poor second to the medium chosen to create the mark, line, or swath of color. But it is important to know about the weight of paper, its relative absorbency, and whether the texture will suit or hinder the smooth passage of your chosen medium.

Type

Choosing paper can be a little like buying clothes or home furnishings: gaining a tactile understanding is really important. Gently rub a sheet of paper between your finger and thumb. Ask yourself whether it feels "right," and trust your judgment.

How a paper reacts when it is drawn on is affected by its absorbency as well as its texture and weight. On a textured paper, for example, the drawing medium (especially if it is dry) only makes contact with the ridges of the paper's surface. Different weights of paper accept ink at different rates and can feel vastly different to draw on. The weight of paper is measured in grams per square meter or "gsm." For example, a watercolor paper might range from 150 gsm to more than 640 gsm, a cartridge paper from 130 gsm to 220 gsm.

The manufacture and fiber content of the paper will greatly affect its absorbency. The best paper is made from 100-percent cotton. It is called rag paper and can withstand water-laden techniques. Wood pulp (from which most papers are made) is cheaper, but less durable, and more likely to stretch when used for wet drawing techniques. Different kinds of sizing—substances added during paper manufacture—also influence the absorbency and resistance of drawing media.

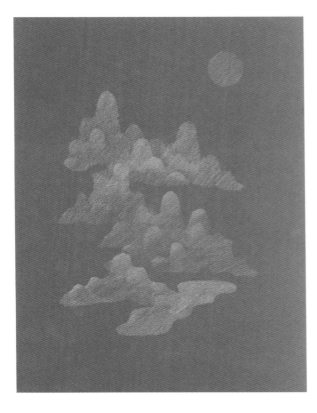

Many different papers (and other surfaces) are available. It's a good idea to have a variety of papers on hand: store-bought and found; white, cream, or colored; plain, lined, or patterned. Some single sheets of paper—handmade or heavy watercolor paper, for instance—can be very expensive, but you can get by spending little or no money. A good art supplies store will have paper sample books. Ask to see them, and don't be afraid to ask questions about which media to use with them.

Cartridge paper is a good general-purpose paper. It is available in different weights and has a smooth surface that is ideal for line work using pen and ink or pencil. Because of their powdery texture, pastels need something to attach themselves to. A rough paper such as Ingres is ideal because it has a tooth. It is perfect for pastel, charcoal, and chalk. Pencil and ink, on the other hand, would catch or snag on its rough surface and their color would "bleed." You can also use watercolor paper or—like many of the artists featured in this book—found papers.

Drawing by Liam Stevens; white pencil on red paper

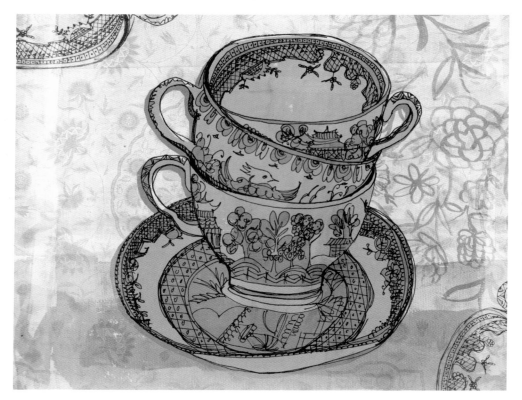

Drawing by
Paula Mills; scanned
wallpaper ground

Format and Size

Format refers to the size of the paper we draw on. Consider paper orientation under this heading too. In drawing we refer to portrait or landscape format. This doesn't refer to the subject matter, but to which way up you use the paper: vertical/upright (portrait) or horizontal/wide (landscape).

The most readily available paper formats are A4 and the US equivalents letter and legal, simply because these are the sizes most often used in laser printers and photocopiers. Many of the other paper and sketchbook sizes are variations of these. (See page 216 for information on international paper sizes.)

The list below will give you an idea of what I use standard sizes for, but these can sometimes make drawings look a bit tired. Why not try a non-standard format?

- 23½ × 33 in (594 × 841 mm/A1): in the life-drawing room, on a drawing board, or standing at an easel
- 23½ × 16½ in (594 × 420 mm/A2): a good desk-sized piece of paper; the largest sketchbook I would use
- 16½ × 11¾ in (420 × 297 mm/A3): the largest easily portable sketchbook size; can be used in some photocopiers, but only professional artists and illustrators tend to have photocopiers for this size at home
- 11¾ × 8¼ in (297 × 210 mm/A4): the most common size for home scanners, printers, and photocopiers, so any drawing you do on this paper can be easily copied or printed; a good size for a sketchbook
- 8¼ × 5¾ in (210 × 148 mm/A5): ideal size for a sketchbook you want to carry everywhere, at all times
- 5¾ × 4 in (148 × 105 mm/A6): a great mini sketchbook size

Color

Color theory is such a complex business I can't do it justice here. The most important thing is to use color with joy and confidence, although it is good to know a few basics too.

The Color Wheel

The color wheel is a useful place to start. It's a simplified version of the color spectrum, arranged as a segmented circle, showing the primary colors (red, yellow, and blue) and the secondary colors created by mixing them (green, orange, and purple). Arranged in this form it's much easier to discuss and visualize color theory.

Color wheel by Kasia Breska. We have added the letters P, S, and T to highlight the primary, secondary, and tertiary colors

Primary colors are those that cannot be made by mixing other colors. It is worth noting, however, that when you buy inks or pigments, there are different names for, and differing qualities of, the primary colors. For example: scarlet or crimson red; lemon or cadmium yellow; cobalt or sky blue. Actually, the list is endless, but with use, you will become familiar with these different reds, yellows, and blues.

You will be more successful at using primary colors, and mixing them to form secondary and tertiary colors, when you understand these differences. It is also worth noting that you get what you pay for. Generally speaking, the more expensive the drawing media, the better the quality of the pigment, binder, mixing ability, longevity, etc., of the colors. Good-quality gouache, for instance, might be marked "student" or "artist." They're both good to use, but the second one is better.

Secondary colors are produced by mixing two primary colors. They will turn out as you want them if you understand the differences between primary-color inks and pigments. A good example is achieving a successful purple, which is a color people often get wrong. "Why does my purple look brown?" is something I often hear. The best red for a purple (blue + red) is crimson-red, which has a bluey quality to it. Scarlet-red has a yellow quality. As soon as you mix that into a blue, it will become a muddy brown.

Similarly, your greens (blue + yellow) will be brighter if you use a blue that sits nearer the greens and yellows on the color wheel. A blue from nearer the reds will make a much darker, more somber green. You may, of course, want that. As with everything, the secret is to experiment.

Tertiary colors, produced by mixing a primary and a secondary color, offer infinite color possibilites.

Tints and Shades

A tint of a color is obtained by adding varying quantities of white to that color, and a shade is obtained by adding varying quantities of black. Note that tints of red become pink and shades of orange become brown (see below).

A drawing made from tinted colors will feel lighter in terms of tonal scale, and in terms of visual weight.

A drawing dominated by shaded colors will feel heavier and moodier. Use both to affect ambience or lighting (night/day, sunny/cloudy), or, perhaps most importantly, as tonal play. Remember: tone does not exist only in the grayscale; it exists in color too. If you want your objects to seem three-dimensional in color, you need to manipulate tints and shades to get the tones of a color.

Left: Drawing by Hisanori Yoshida; tints and shades (see entry on page 90)

Below: Orange and red are unusual in that their shades/tints become separate colors: shades of orange become brown (top) and tints of red become pink (bottom)

Harmonious or Related Colors

These colors sit together on the color wheel. When used in a drawing they will give it a distinct characteristic of "togetherness" or harmony.

Complementary Colors

These colors sit opposite one another on the color wheel. They will make a drawing feel more punchy, as each brings out the opposite quality in the other.

Right: Drawing (cropped) by Betsy Walton; complementary colors

Far right: Drawing by Hisanori Yoshida; harmonious colors

Techniques

Stretching Paper

Sometimes you'll choose to do drawings using a wet medium such as watercolor or ink, or want to lay down a painted background. Some heavier papers will absorb the liquid and remain relatively unchanged by this, but less robust papers will buckle or distort when the wet medium is added. If you don't want any distortion—which you won't if you want to scan your work, use it as the base for a collage, or frame it—you can prevent this by stretching the paper.

How to Stretch Paper

1. Cut or tear a length of gummed brown tape for each edge of the paper. Make these a little longer than the paper edges to allow for overlap.

2. Dampen the paper with a sponge. This will relax the paper's fibers.

3. Tape the paper to a clean drawing board (or an offcut of MDF, medium-density fiberboard). Use the sponge to wet the brown tape, one strip at a time, and stick one strip along each length, half on the paper, half on the drawing board.

4. As the paper dries and its fibers become less relaxed again, a tension builds on the surface. This pulls against the gum tape, and the paper becomes perfectly flat. You can use any wet medium and it will stay flat.

5. Do not cut the finished drawing off the board until it is completely dry, or it will ripple, buckle, and distort again.

Online Image Sharing

Websites

A recent, positive development for drawing is the availability of excellent examples of drawing online. So many artists and illustrators are willing to share their work, and this is a good way for them to have an online portfolio and make their work known. If you want to share your drawings, or research the work of others, some of the best sites are listed below.

Flickr.com

Flickr is one of the most popular image-sharing sites on the web, and definitely not just for photographs. Many illustrators use it as a virtual exhibition space for their work. It's a really good space to link up with others and to follow or comment on their work.

23hq

Another image-sharing site, 23hq is a free resource that allows individuals to share, archive, and organize their visual material.

Pinterest.com

This site allows you to organize things you find on the web. It has a pinboard-style layout and is a good place to keep in one place things you'd otherwise browse on many sites. You can share your findings with others, or keep them secret. It's where you'll often find me pinning drawings: **pinterest.com/drawdrawdraw/2d**

Behance.net

Behance describes itself as a "platform to showcase and discover creative work." It is used by professionals, both those making work and those buying or commissioning work. Although you can't upload your own material (unless someone recommends or invites you), it's an invaluable resource when looking for designed visuals, including drawing.

Blogs

Artists' blogs are another great source for drawing ideas. They are usually maintained by an individual and this means you get a real sense of that person's interests, style, research sources, and so on. You will often find links to them from an artist's website.

You could consider starting your own drawing blog, but if you want to commit less time to blogging, try Twitter.com (sometimes referred to as a micro-blogging site). Lots of people provide links to drawing works there. The trick is to follow the right people. It can take time to build up a network, but it's worth it.

I can give you a head start with:
twitter.com/drawdrawdraw
drawdrawdraw-drawdrawdraw.blogspot.co.uk

It is also worth considering looking at artists' Facebook pages, and creating your own (www.facebook.com).

Screengrab of a page from the author's 23hq account

International Paper Sizes

There are three main systems of paper sizes used around the world: the International Standards Organization system (ISO), used everywhere except the USA, Canada, and Japan; the American National Standards Institute (ANSI) system, used in the United States; and the Japanese Industrial Standard (JIS), used in Japan and Taiwan. The Canadian Standard (CAN) system uses the ANSI paper sizes rounded to the nearest ¼ in (5 mm).

ISO series

The ISO system is based on the metric system. It has five series of paper sizes. The A series is the most recognized and includes A4, the standard European letterhead size. The rarely used B series provides sizes intermediate to the A series. The C series is used mainly for envelopes, postcards, and folders. A C4 envelope holds an unfolded A4 sheet. The RA and SRA series are used mainly by printing houses. They are sheets of untrimmed paper that allow for grip, trim, and bleed. Printing presses cannot print right to the edge of a sheet because the excess ink buildup would cause problems, so they use these oversized sheets, which they trim down to size after printing.

ANSI series

The ANSI system, adopted in the USA in 1995, is based on the standard "US Letter" size, which is called "ANSI A" (and often referred to as American Quarto outside the USA). The already existing "US Ledger/Tabloid" size is included in the series as "ANSI B." However, the most commonly used everyday paper sizes in the USA and Canada are the "loose sizes" of "letter," "legal," "ledger," "tabloid," and "broadsheet."

JIS series

The JIS system uses two series of paper sizes: JIS A and JIS B. The JIS A series is almost identical to the ISO A series, but the JIS B series is completely different, having an area 1.5 times that of the corresponding A-series paper.

ISO A-series paper sizes

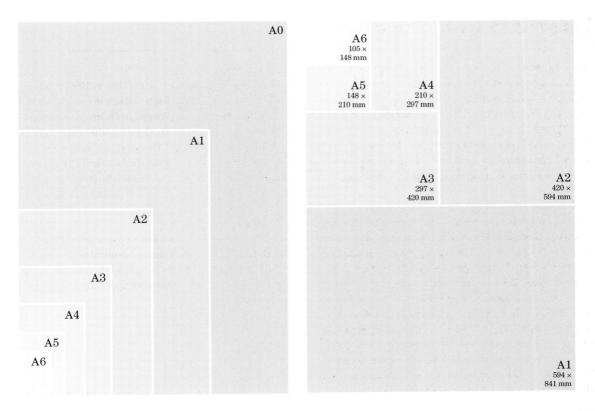

A0

A1

A2

A3

A4

A5

A6

A6
105 ×
148 mm

A5
148 ×
210 mm

A4
210 ×
297 mm

A3
297 ×
420 mm

A2
420 ×
594 mm

A1
594 ×
841 mm

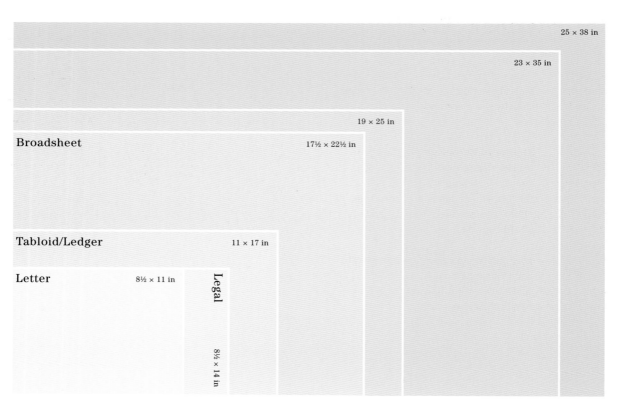

25 × 38 in

23 × 35 in

19 × 25 in

Broadsheet

17½ × 22½ in

Tabloid/Ledger

11 × 17 in

Letter

8½ × 11 in

Legal

8½ × 14 in

International Pencil Grades

The hardness, or softness, of a pencil is given as a grade. The number of grades offered differs from one manufacturer and one range to another. The grades themselves are not always consistent as there is no official standard.

The system used by most European manufacturers, and by American firms that produce pencils for artists, generally runs from 10B (the softest) to 10H (the hardest). The "B" stands for "black" and the "H" for "hard." An "F" rating ("fine" or "firm") is also used. On the scale from 10B to 10H, F and HB come in the middle.

In the US, a number-only system is also used, generally for office stationery. This runs from 1 to 4, with 1 having the softest lead and 4 the hardest. The table, right, shows the approximate equivalents between the two systems.

US	UK/European
1	B
2	HB
2.5	F
3	H
4	2H

Left: North American paper sizes

Contributors

Ana Montiel
http://www.anamontiel.com

Angela Dalinger
http://angeladalinger.tumblr.com
http://angela-dalinger.jimdo.com

Betsy Walton
betsy@morningcraft.com
http://www.morningcraft.com

Bovey Lee
http://boveylee.com
http://boveylee.wordpress.com

Bryce Wymer
http://brycewymer.com
http://brycewymer.blogspot.co.uk

Caitlin Foster
http://caitlinfoster.tumblr.com

Carine Brancowitz
http://www.carinebrancowitz.com
http://facebook.com/carinebrancowitz

Catherina Turk / dear pumpernickel
http://catherinaturk.blogspot.com
http://www.etsy.com/shop/
　dearpumpernickel

Cheeming Boey
boey@iamboey.com
http://iamboey.com
http://www.facebook.com/
　BoeyCheeming
http://twitter.com/iamboey

Chris Keegan
info@chriskeegan.co.uk
http://www.chriskeegan.co.uk

Craig McCann
http://www.fishink.co.uk
http://www.fishinkblog.wordpress.com
http://fishink.carbonmade.com/
　projects/4182518

Dain Fagerholm
http://dainfagerholm.com

Dale Wylie
dale_wylieone@hotmail.com

David Gomez Maestre
http://www.davidgomezmaestre.com/web

Diego Naguel
http://www.diedie.com.ar

Donny Nguyen
donny@donnynguyen.com
http://www.donnynguyen.com

Emanuele Kabu
tet5uo@hotmail.it
http://www.emanuelekabu.org

Emily Watkins
http://www.emily-watkins.co.uk

Fred One Litch
freddiethepainter@yahoo.com
http://www.flickr.com/photos/34700121@N04

Frida Stenmark
fridastenmark@gmail.com
http://ohmondieu.blogg.se

Hisanori Yoshida
hisanoriyoshidajp@yahoo.co.jp
http://hiruneweb.com

Hollis Brown Thornton
http://www.hollisbrownthornton.com

Isaac Tobin
http://www.isaactobin.com

Jamie Mills
http://jamiemillsillustration.
 blogspot.co.uk

Jamie Palmer / Pen & Gravy
penandgravy@gmail.com

Jane Pawalek
janepawalek@rocketmail.com

**Jean-Charles Frémont /
have a nice day**
http://www.haveaniceday.me
http://works.haveaniceday.me
http://bealooser.tumblr.com
http://handgif.tumblr.com
http://motsgif.tumblr.com
http://motsgifcolors.tumblr.com

Jeffrey Decoster
http://www.jeffreydecoster.com

Jennifer Davis
http://www.jenniferdavisart.blogspot.com
http://www.jenniferdavisart.com

Julia Pott
http://www.juliapott.com

Jung Eun Park
red-colored@hotmail.com
http://www.jungeunpark.com
http://jungeun.tumblr.com

Kasia Breska
http://twitter.com/PencilBoxGirl
http://kasiabreska.yolasite.com
http://pinterest.com/pencilboxgirl/pins

Kate Pugsley
http://www.katepugsley.com

Kaye Blegvad
http://www.kayeblegvad.com

Kelly Lasserre
http://www.kellylasserre.com

Kristen Donegan
http://bkdonegan.blogspot.co.uk

Leah Goren
http://www.leahgoren.com

Liam Stevens
liam@liamstevens.com
http://www.liamstevens.com

Lisa Naylor
lisanaylorartist@hotmail.com
http://www.lisanaylorartist.co.uk

Lyvia Aylward-Davies
lyviaalexandra@me.com
http://oliverandlyvia.tumblr.com

Manuel San Payo
manuelsanpayo@me.com

Marina Molares
marinamolares@gmail.com
http://marinamolares.com

Mark Lazenby
mark@marklazenby.co.uk
info@gloryillustration.com
http://www.marklazenby.co.uk
http://www.gloryillustration.com

Nayoun Kim
nyhy0616@gmail.com
http://nykillustration.blogspot.kr
http://www.nayounkim.com
http://society6.com/NayounKim/prints

Nikki Painter
http://nikkipainter.com

Olya Leontieva
leontieva.olya@gmail.com

Pablo S. Herrero
http://lasogaalcielo.blogspot.com.es

Paolo Lim
paolo.y.lim@gmail.com
http://www.supersteady.org

Paula Mills
http://www.paulamillsillustration.com

Peter Carrington
peter.carrington@ymail.com
http://petercarrington.co.uk
@PeterCarrington

Pia Bramley
hello@piabramley.co.uk
http://www.piabramley.co.uk
http://www.piabramley.tumblr.com

Rosalind Monks
info@rosalindmonks.com
http://www.rosalindmonks.com

Sandra Dieckmann
http://www.sandradieckmann.com
http://sandradieckmann.blogspot.com
http://www.etsy.com/shop
@sandradieckmann

Sara Landeta
http://www.saralandeta.com
http://www.facebook.com/pages/
Sara-Landeta-Artista/139206052849076

Sarah Esteje
http://abadidabou.tumblr.com

Sophie Leblanc
http://www.sophieleblanc.com

Sophie Lécuyer
mllesophielecuyer@gmail.com
http://sophielecuyer.blogspot.com
http://sophielecuyer.ultra-book.com

Stephanie Kubo
mail@stephaniekubo.com
http://www.stephaniekubo.com

Steve Wilkin
steve.wilkin@btinternet.com
http://www.stevewilkin.co.uk

Timothy Hull
http://www.fridaynotes.com

Valerie Roybal
http://valerieroybal.com
http://valerieroybal.tumblr.com

Valero Doval
http://www.valerodoval.com

Violeta Lopiz
violopiz@yahoo.es
http://www.violetalopiz.com

Wendy Marchbanks
wendy@marchbanks.co.uk

Whooli Chen
http://www.behance.net/whoolichen

Index